Vincent Van Gogh:
120 Drawings and Watercolors

By Narim Bender

First Edition

<u>Vincent Van Gogh:</u>
<u>120 Drawings and Watercolors</u>

Copyright © 2014 by Narim Bender

Foreword

Vincent van Gogh (1853-1890) drew thousands of images to better his style. He believed that drawing was "the root of everything" and completed over 1,000 drawings from 1877 to 1890.

In a letter Vincent wrote in 1880 to his brother Theo:

"Well, and yet it was in these depths of misery that I felt my energy revive and I said to myself, I shall get over it somehow, I shall set to work again with my pencil, which I had cast aside in my deep dejection, and I shall draw again, and from that moment I have had the feeling that everything has changed for me, and now I am in my stride and my pencil has become slightly more willing and seems to be getting more so by the day. My over-long and over-intense misery had discouraged me so much that I was unable to do anything."

Van Gogh's drawings were mainly done in pencil, black Chalk, red Chalk, blue Chalk, reed pen and Charcoal on a variety of paper types these included Ingres paper, laid paper, wove paper. At the outset of his career, he felt it necessary to master black and white before attempting to work in color. Thus, drawings formed an inextricable part of his development as a painter. There were periods when he wished to do

nothing but draw. Although his paintings are much more popular than his drawings, Van Gogh is considered a master of drawing.

Vincent van Gogh began to draw as a child, and he continued to draw throughout the years that led up to his decision to become an artist. He did not begin painting until his late twenties, completing many of his best-known works during the last two years of his life. In just over a decade, he produced more than 2100 artworks, consisting of 860 oil paintings and more than 1,300 watercolors, drawings, sketches and prints. He produced nearly 150 watercolor paintings during his life.

Similar to his drawings, Van Gogh often did watercolors as studies before doing an oil painting or as practice. As he continued to refine his technique, he used more and brighter colors in his watercolors. In the letter to his brother Theo, in December of 1888 Van Gogh wrote the following:

"...They (a few watercolors) are not masterpieces, of course, yet I really believe that there is some soundness and truth in them, more at any rate than what I've done up to now. And so I reckon that I am now at the beginning of the beginning of doing something serious...They may still be full of imperfections, que soit, I am the first to say that I am still very dissatisfied

with them, and yet they are quite different from what I have done before and look fresher and brighter. That doesn't alter the fact, however, that they must get fresher and brighter still, but one can't do everything one wants just like that. It will come little by little."

Though oftenthey are far away from his bold brush strokes, the Van Gog's watercolors are a unique in their use of clear and vibrant colors.

Drawings and Watercolors

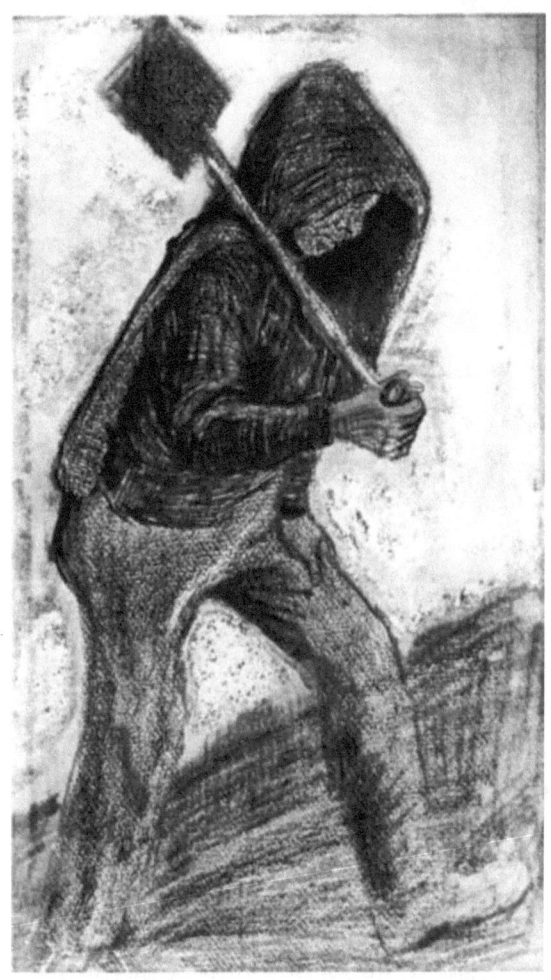

Coal Shoveler

1869, pencil, Chalk, ink

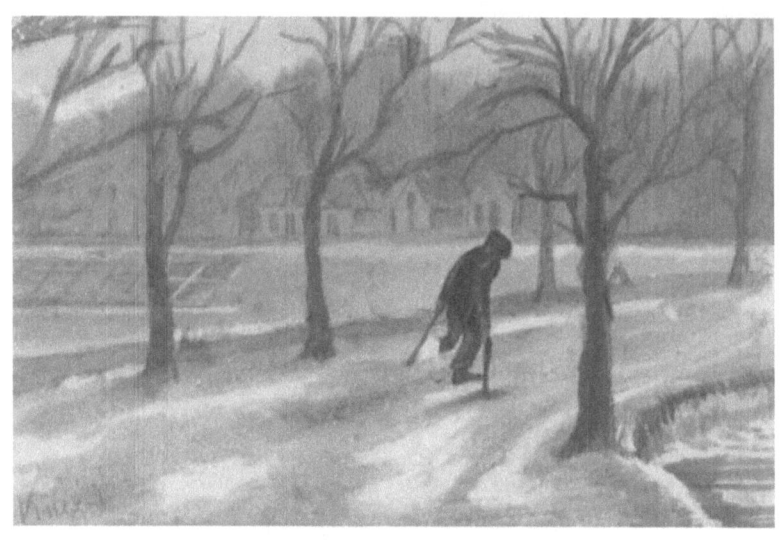

Winter, in life as well (after Jozef Israëls)

1877, Pencil, Watercolor and ink on paper, 14.5 x 21.5 cm, Private Collection

By the age of 27 Vincent van Gogh could look back on a disastrous professional career: in about ten years time he had failed as an employee at an art dealer, as a teacher and had given up another job at a bookshop in order to study theology in Amsterdam. After a temporary position as an evangelist in the Belgian Borinage, which was not prolonged, he spent almost a year reflecting on his future. It was not until 1880 when he, persuaded by his brother Theo, decided to become an artist.

It was presumably during the preparation for his theology studies (which he would never start), in 1877, that Van Gogh painted Winter, in life as well. The watercolor belongs to a small group of early works Van Gogh made between 1872 and 1880. In these days Van Gogh was drawing without any pretension and without feeling the need to explore the possibilities of the different materials. Some of these drawings are somewhat unwieldy, while others have a striking resemblance to real life.

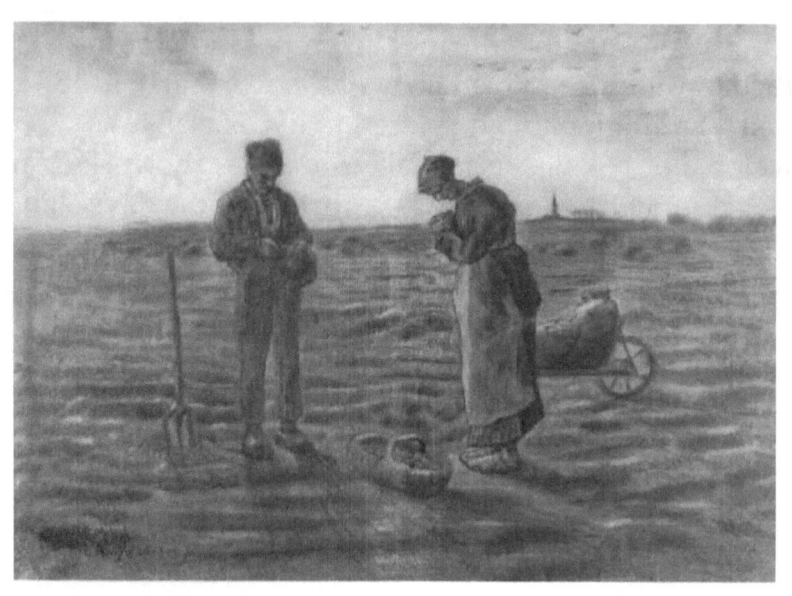

The Angelus (after Millet)

1880, Chalk

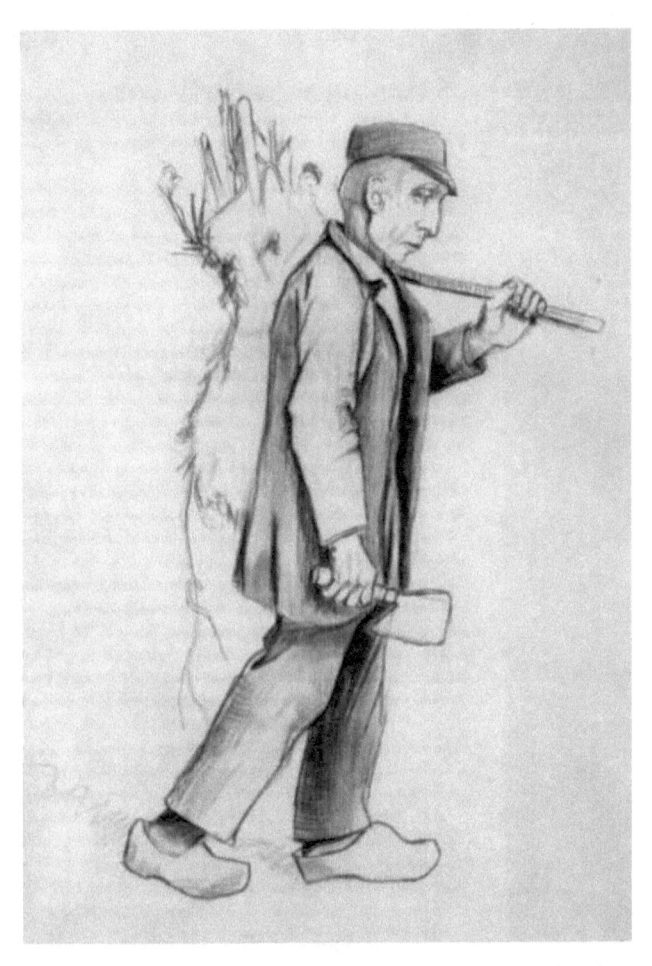

Man with a Sack of Wood

1880, Chalk

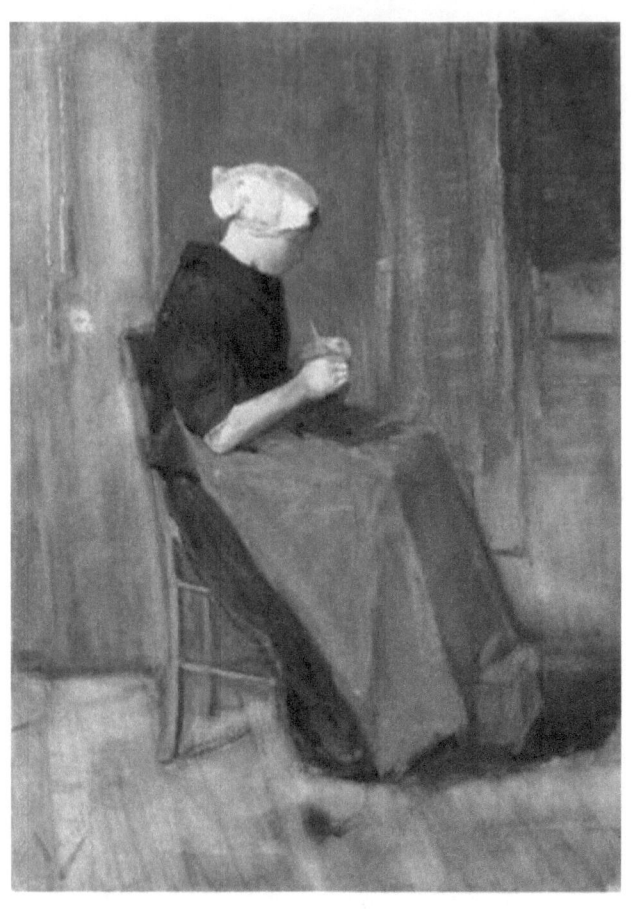

Young Woman, Knitting: Facing Right

1881, Watercolor and Gouache on paper, 52.2 x 36.5 cm, Private Collection

Painted in December 1881, the present work was completed while van Gogh was studying art under the tutelage of his cousin Anton Mauve in The Hague. A distinct change was visible in Vincent's work as a result of his working with Mauve. Mauve instructed Vincent

to focus on still-lifes--an old pair of clogs and other objects, and to try his hand at watercolor. As Vincent recorded in a letter to his brother, Theo, "I can not tell you how kind and cordial Mauve and Jet [Mauve's wife] have been to me during this time. And Mauve has shown me and told me things that I may not be able to do right away but will gradually be able to put into practice"

In another letter Theo, the artist wrote:

"I still go to Mauve's everyday - in the daytime to paint, in the evening to draw. I have now painted five studies and two water colors and, of course, a few more sketches... The painted studies are stilllifes, the watercolors are made after the model, a Scheveningen girl...through Mauve I have got some insight into the mysteries of the palette and of water coloring... I confidently hope that I shall be able to make something salable in a relatively short time. Yes, I even think that these two would be salable in case of need. Especially the one which Mauve has brushed a little. But I would rather keep them myself for a time in order to remember better some things about the way in which they are done..."

On 7 July 1882, van Gogh again referred to this watercolor in a letter to Theo:

"This afternoon I at once sent a drawing to the doctor who treated me...to show my gratitude. It was a Scheveningen girl knitting; done at Mauve's studio, and really the best watercolor I had..."

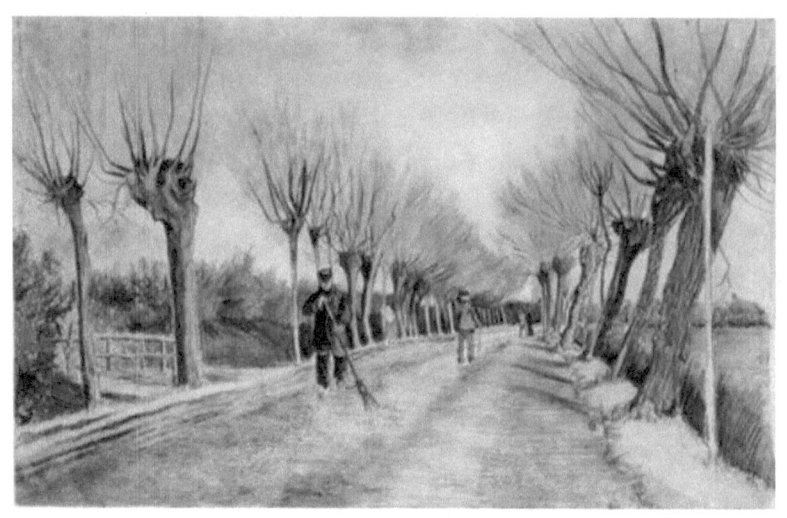

Road in Etten

1881, Chalk, pencil, pastel, watercolor, 39.4 x 57.8 cm, Metropolitan Museum

In the fall of 1881, Van Gogh briefly resided in Etten, where he produced a number of drawings of local peasants and laborers performing routine, humble tasks. This masterful work, in which a man with a broom is seen sweeping a street lined with pollard willows, is a characteristic example.

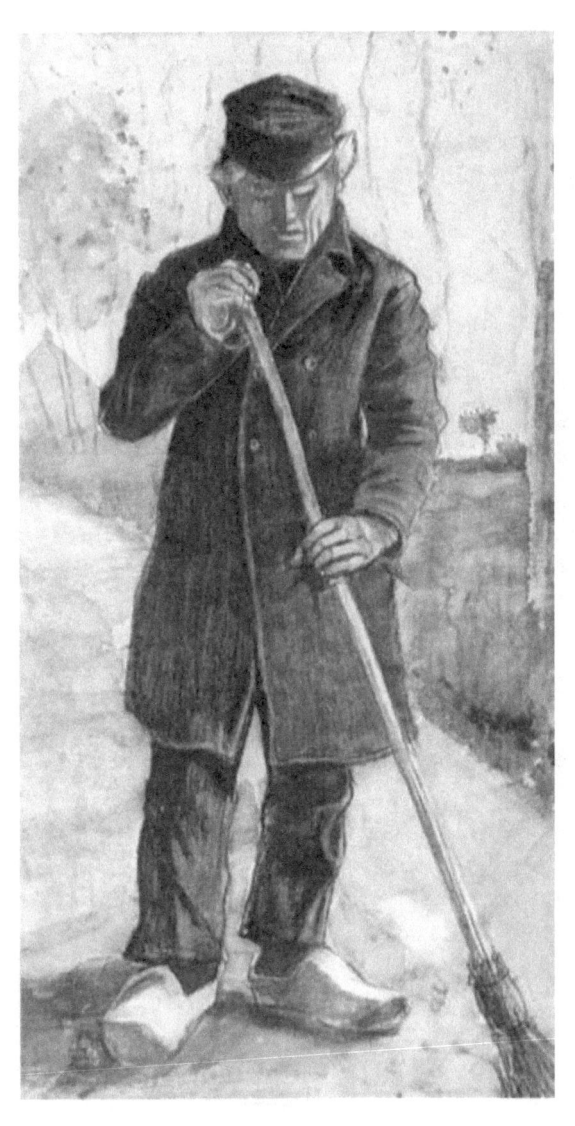

A Man with a Broom

1881, Chalk

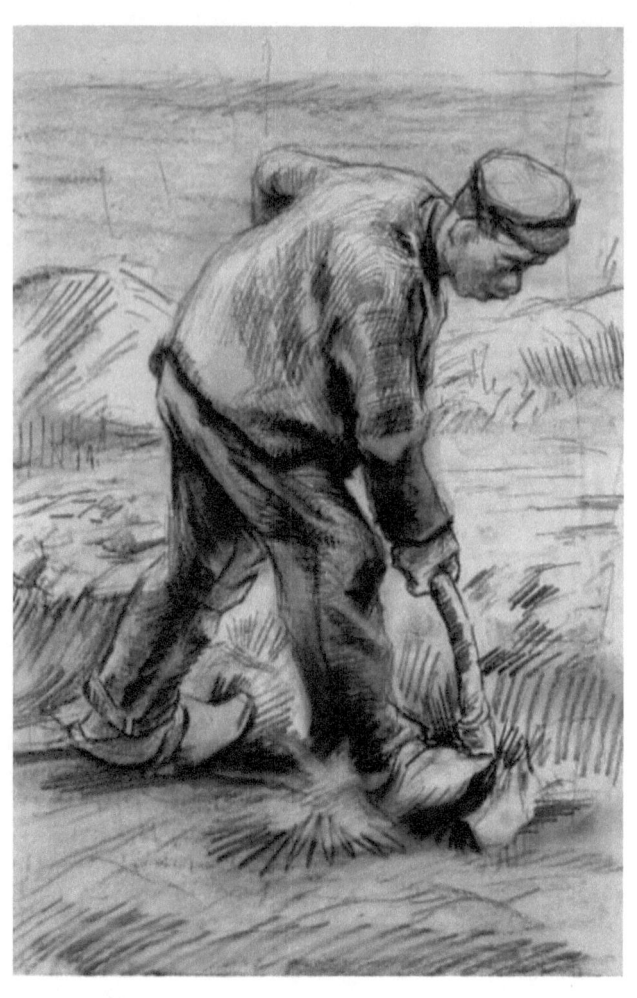

Digger

1881, Chalk

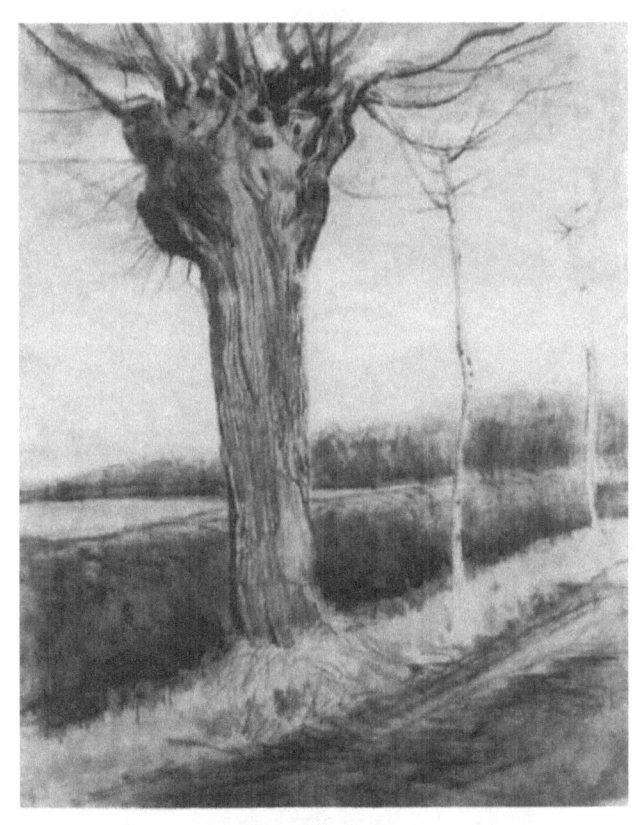

Pollard Willow

1881, Chalk

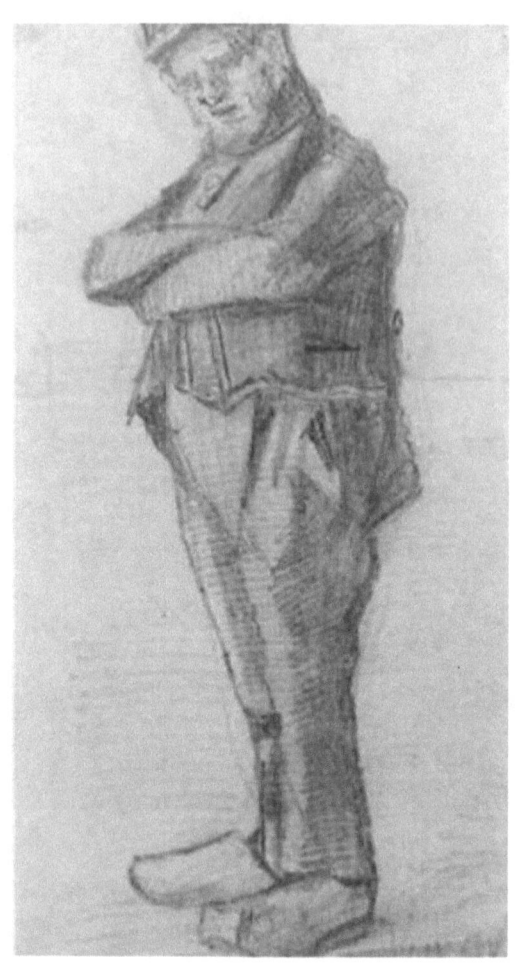

Standing man with folded arms

1882, Charcoal on paper, 31.5 x 16 cm, Metropolitan Museum

This drawing as a study for the male figure in Van Gogh's detailed drawing Fish-drying barn in Scheveningen of 1882, which is housed in the Kröller-Mller Museum, Otterlo. Only a few drawings of single figures are known from this period.

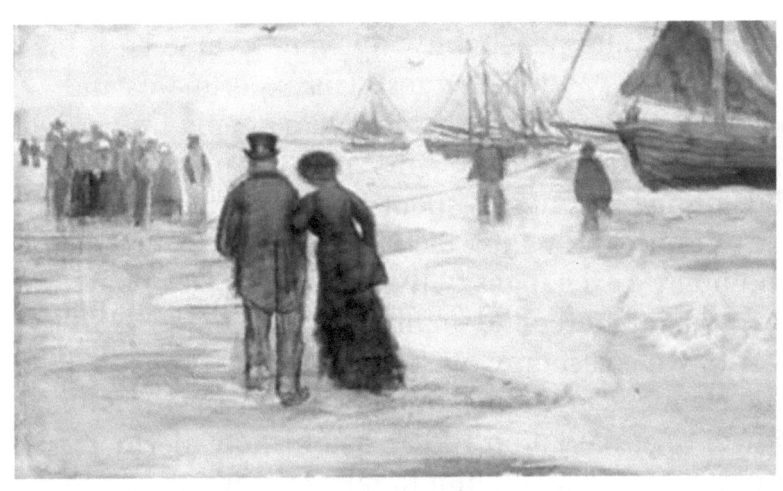

The Beach at Scheveningen

1882, Gouache, Watercolor and Charcoal on paper, 27.8 x 46cm, Private Collection

In December 1881 Van Gogh moved to The Hague, where he remained until September 1883. He had fled to the Dutch coastal city exasperated by a serious row with his parents which exploded around Christmas 1883. But he immediately adapted to the new surroundings and the twenty months he spent here gave him 'moments of domestic bliss that were not to fall to his lot again'. Although he had first looked for a place in the picturesque fishing village of Scheveningen, his financial situation did not allow him to rent a room in what was becoming a home for bohemian artists and a fancy resort - he was thus compelled to settle in Schenkstraat, on the edge of the town. He found a small studio, with enough light for him to work, and embarked upon an exciting experimental journey, marked by the enthusiastic discovery of new drawing and painting techniques.

watercolor and pencil drawing were soon to be at the centre of his passionate quest. His experiments and achievements with watercolor were deeply influenced by the example of his cousin Anton Mauve, with whom the young Vincent had spent a very formative stay in the autumn and winter of 1881. Van Gogh's productive and intense exchanges with Mauve, by 1882 a renowned painter and an influential man in the art-world, were certainly one of the brightest spots of the The Hague years. Van Gogh possessed an enormous power of assimilation and an astonishing alertness of mind, which enabled him to take in many things in a short time and to learn from others. Some of his watercolors are very close to Mauve's'.

The Beach at Scheveningen, like The poor and money and Young Scheveningen woman, knitting, are amongst the most clearly indebted works to Anton Mauve's technical and aesthetical lesson. But unlike the other watercolors executed in the autumn of 1882, The Beach at Scheveningen is not a depiction of the destitute and the poor of Schenkstraat; on the contrary, it is a snapshot of a bourgeois Sunday stroll on the beach. A lighter palette matches Van Gogh's less biting tone and less engaged choice of subject. The colors are not played around the earthy hues of his contemporary compositions, but on delicate nuances of pink, beige and blue, heightened by the red of the fishermen's' blouses. The attentive observation of the couple promenading on the shore, the impressionistic rendition of the landscape and careful use of the perspective concur to a composition of great balance and freshness, unburdened by the anguish and darkness of Vincent's Hague works.

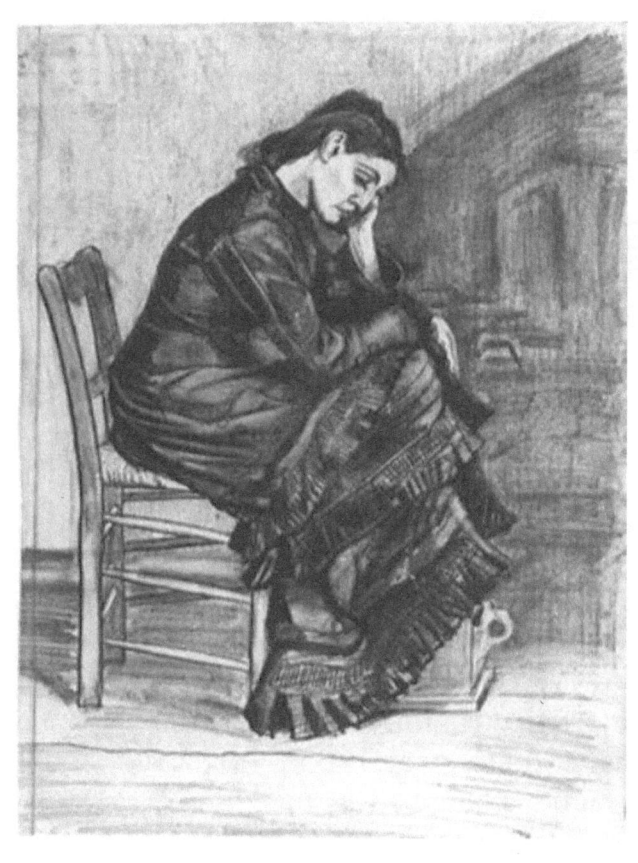

Bent Figure of a Woman, (Sien?)

The Hague: May - early in month, 1882, Drawing, Pencil, pen, brush, sepia, washed, Kroller-Muller Museum

Nursery on the Schenkweg

1882, Reed pen and iron gall ink; brush and wash; touches of Gouache and scraping on laid paper, 29.6 x 58.5 cm, Metropolitan Museum

Van Gogh's first commission came from his uncle Cornelis Marinus, an art dealer, for drawings of views of the Hague, where he was then living. This large view of a nursery close to Van Gogh's studio was among those he sent to Marinus in May 1882.

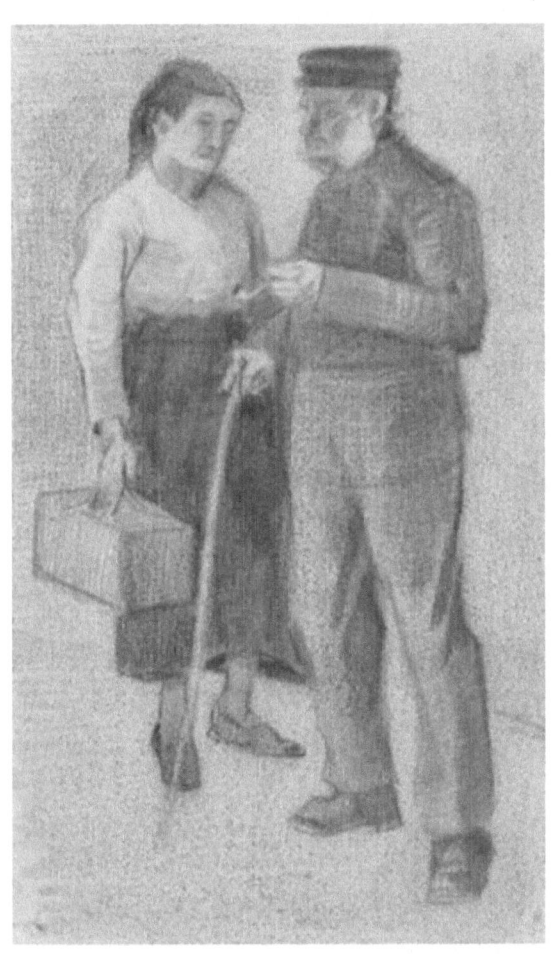

Old Man and Woman

1882, black lithographic crayon over pencil with white heightening on paper, 47.5 x 27.5 cm, Private Collection

Executed in The Hague in late 1882, Old Man and Woman is one of only eight drawings to be added to the recognized of Van Gogh. The present work was accepted by the Van Gogh Museum on several

significant bases: its materials - rubbed black lithographic crayon over the heavy carpenter pencil which Van Gogh favored for its sturdy application; recognizable models--Adrianus Zuyderland, whose wizened features and distinctive white side-whiskers appear frequently in Van Gogh's contemporary figure studies and his aged companion.

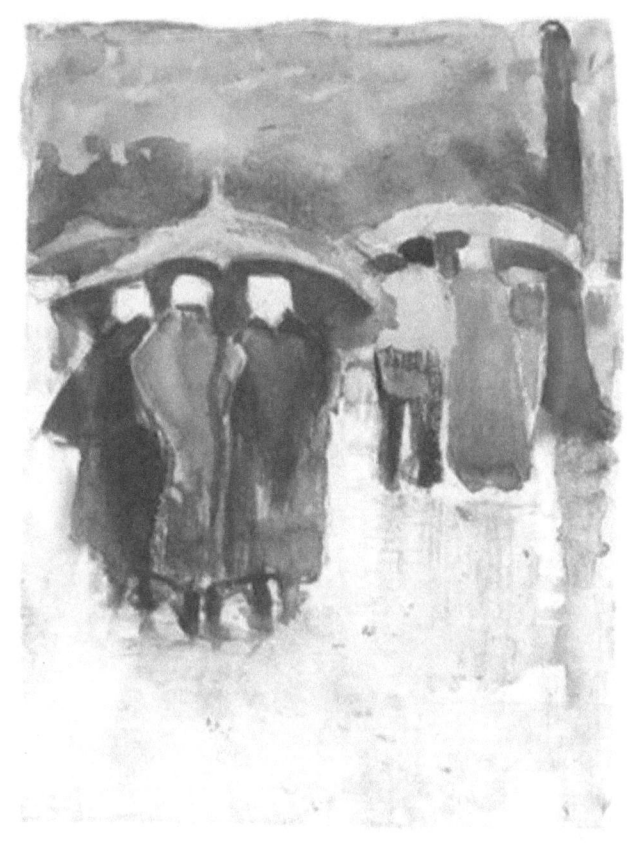

Scheveningen Women and Other People under Umbrellas

1882, Watercolor, Gemeentemuseum Den Haag

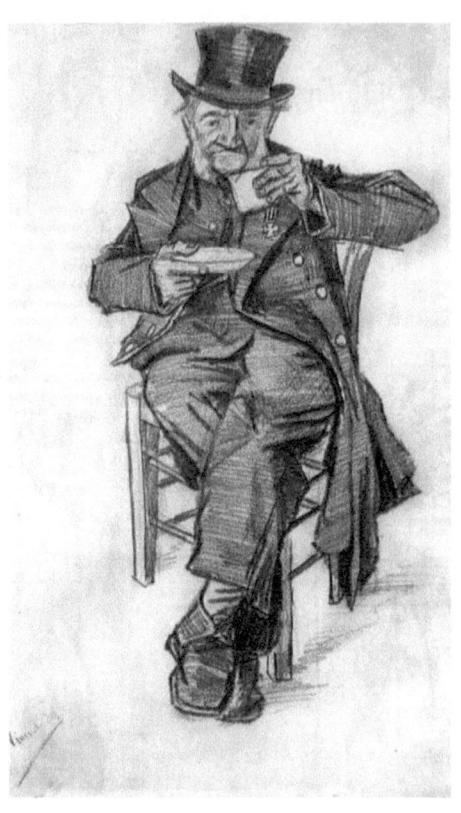

Orphan Man with a Top Hat Drinking a Cup of Coffee

1882, Black Chalk, Watercolor and wash on paper, 49.6 x 30 cm, Private Collection

Executed in November 1882, Orphan Man with Top Hat, Drinking Coffee is one of Van Gogh's most powerful portraits of Adrianus Zuyderland, one of the residents of the Reformed Old People's Home in The Hague, whom he first saw in September of the same year and who became one of his favorite subjects alongside Sien and her family. In early September 1882, Vincent wrote to Van Rappard: 'I also recently got a

man from the Old Men's Home to serve as a model'. Zuyderland caught the artist's attention thanks both to his striking appearance ('He has a nice bald head... and white whiskers' (Letter 235)) and his versatility as a model, lending himself to the most diverse compositions. His attire was quite impressive: he is very often depicted with a long overcoat, sometimes decorated with military insignia (a paradoxical reminder of past glory), wearing a rather emphatic top hat, holding a cane or a more prosaic umbrella.

Van Gogh caught Zuyderland in the most menial moments of his humble day, eating his soup, warming himself by the stove, holding his beer, or, in a series of works among which is numbered the present drawing, drinking his coffee. Van Gogh studied this composition very carefully, since he used it as basis for one of his first attempts at lithography, of which he wrote enthusiastically to his brother:

'Along with this letter you will receive the first proofs of... a lithograph of a 'Man Drinking Coffee... The drawings were better. I had worked hard on them...'

The fascination Zuyderland held for the artist is evident in the present work. In some sheets the old man sported an austere, almost defiant look, standing proud in his overcoat, as if he was daring the essential poverty of his surroundings. But in the most poignant drawings, Van Gogh has captured him off guard, defeated by his miserable state, as in the present drawing, or in the famous Old Man with his Head in his Hands, a manifesto of despair, where Zuyderland became almost the alter ego of Sien in Sorrow.

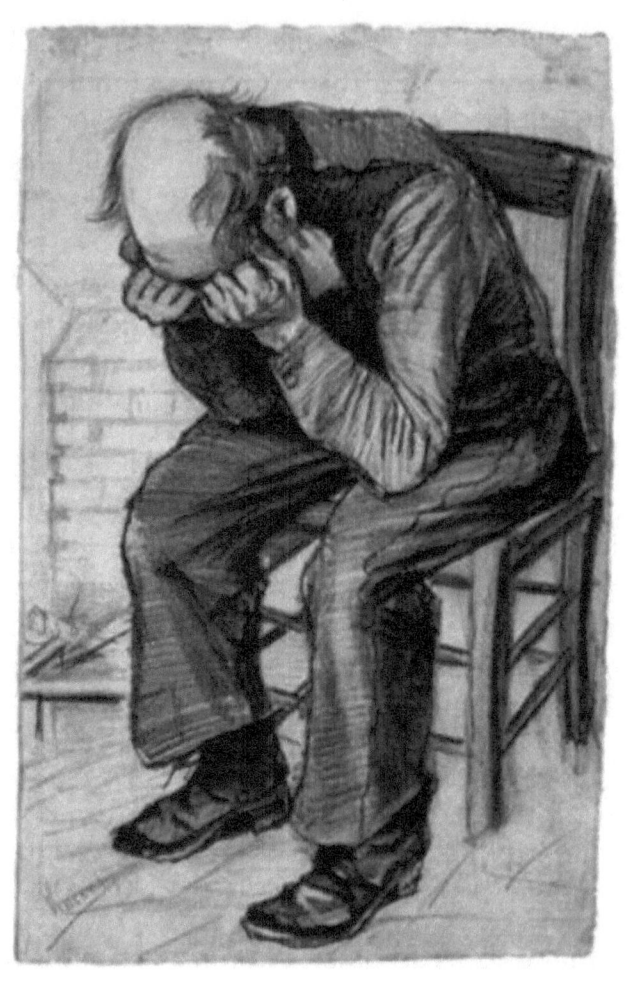

Old Man with His Head in His Hands

1882, Drawing, Pencil on watercolour paper, Van Gogh Museum

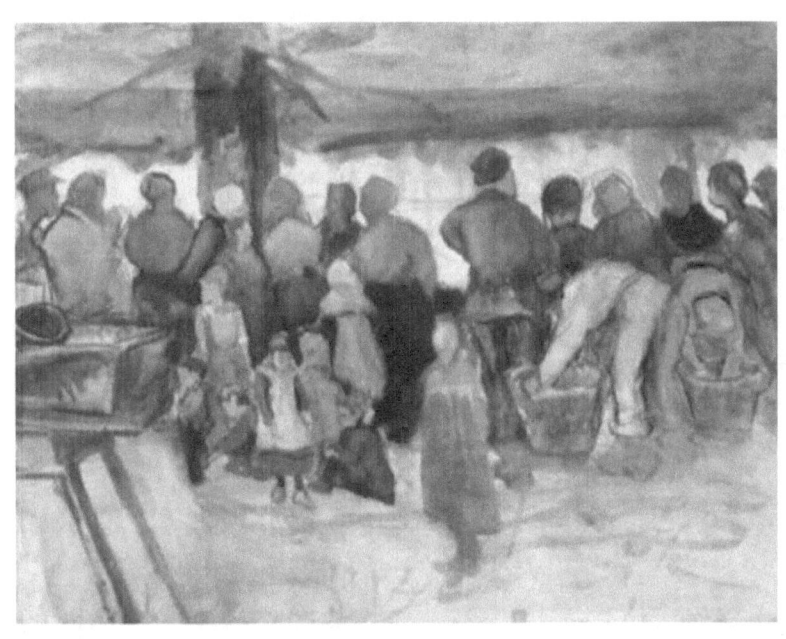

The Potato Market

1882, Watercolor on paper, 44 x 56cm, Private Collection

In December 1881, after a very formative year's stay with the Hague painter Anton Mauve, Van Gogh moved to The Hague, where he remained until September 1883. Fired by the example of Millet, whom he took as a mentor for both his spiritual and artistic development, between September and October 1882 Van Gogh found his inspiration for a series of important watercolors in the markets and villages surrounding Schenkstraat. On 9 September, he described to Theo the potato market which had become the focus of his sketches, in preparation of the present

more complex, larger watercolor. Around 1 October he wrote to Theo emphasizing his relentless work on the same series of watercolors, among which is also The Poor and the Money, the Van Gogh Museum's only large watercolor from the Hague period. The Potato Market and The Poor and the Money are extremely close, in tone and style: they share an almost identical format and display of the figures on the pictorial surface; a similar sense of perspective; and above all, the same palette, splendidly played around the earthy hues that will become the hallmark of Van Gogh undisputed masterpiece of the Neunen phase, The Potato Eaters (1885, Amsterdam, Rijksmuseum Vincent van Gogh).

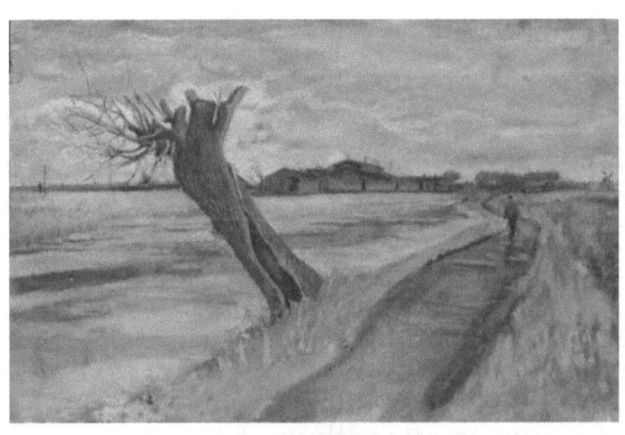

Pollard Willow

1882, Watercolor, Gouache and pen and ink on paper, 37.7 x 56.2 cm, Private Collection

'I've attacked that old giant of a pollard willow, and I believe it has turned out the best of the watercolours. A sombre landscape - that dead tree beside a stagnant pond covered in duckweed, in the distance a Rijnspoor depot where railway lines cross, smoke-blackened buildings - also green meadows, a cinder road and a sky in which clouds are racing, grey with an occasional gleaming white edge, and a depth of blue where the clouds tear apart for a moment' (Van Gogh, letter 252 to Theo, 31 July 1882).

Vincent van Gogh's Pollard Willow was created on 27 July 1882, at a crucial moment during his formative stay in The Hague that year. This forceful image, with the blasted and withered expressive form of the tree in the foreground and the meticulously-detailed landscape behind it, reveals Van Gogh's incredible enthusiasm for the area surrounding his home there as well as his profound love of nature. It also introduces

the concept of the landscape as a vehicle for feelings and sentiments, a factor that he would continue to develop for the rest of his career, arguably culminating in the landscapes he would create over half a decade later in the South of France. It is telling that some of those later landscapes would continue to explore the theme of pollard trees. With its gnarled form, the tree in Pollard Willow dominates the landscape like a human figure; it takes on an anthropomorphic role that continues in those later images, allowing Van Gogh to project his own emotions through this pollard proxy.

Van Gogh wrote to his brother the day before he made Pollard Willow giving a vivid description of the landscape near his abode, and revealing that he had already marked out this tree in particular:

'When you come I know of a few lovely paths through the meadows where it's so quiet and peaceful that you'll be delighted. I've discovered old and new laborers' cottages there, and other houses that are distinctive, with small gardens lining the banks of the ditch - really charming. I'm going to draw there early tomorrow morning. It's a pat through the meadows from Schenkweg to Enthoven's factory or Het Zieke. I saw a dead pollard willow there, just the thing for Barye, for example. It hung over a pond with reeds, all alone and melancholy, and its bark was scaled and mossy, as it were, and marbled in various tones - something like the skin of a snake, greenish, yellowish, mostly dull black. With white flaking spots and stumpy branches. I'm going to attack it tomorrow morning' (Van Gogh, letter 251 to Theo, 26 July 1882).

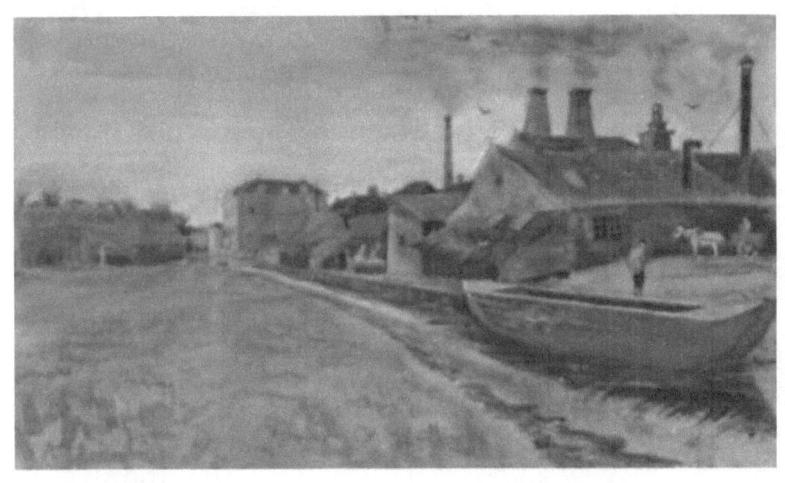

The Iron Mill in The Hague

1882, Gouache, Watercolor, wash, pen and India ink and pencil on paper, 35.8 x 60.4 cm, Private Collection

Van Gogh painted The Iron Mill in The Hague at a crucial juncture in his early development as an artist. Previously he had made numerous Chalk and ink drawings, washed drawings, and largely monochromatic watercolors. He was still only comfortable in working within a limited range of tonal values, and had little understanding of how to use the expressive possibilities of color. He was indeed a late starter; he was almost thirty years old and had not yet tried his hand at oil painting, the real test of a young artist's progress and skills. Nevertheless, during the early months of 1882 that he spent in The Hague, he

made tremendous strides in his draughtsman ship, and acquired a useful understanding of perspective. He put these means to use in a series of carefully composed and executed watercolors, including the present work, which were more opaquely rendered than previously and heightened with white body-color, that he painted in the late spring and early summer. In August, less than a month after he painted The Iron Mill, van Gogh made his first oil paintings.

It was a time of significant development in van Gogh's personal life as well. He had begun a liaison with a pregnant prostitute, Sien. He was also hospitalized after contracting a venereal disease. During the spring of 1882, prior to his hospital stay, van Gogh had been concentrating on landscapes with figures, in addition to figure drawings for which Sien and members of her family had served as models. The principal motivation for the landscapes was a commission from the artist's uncle, Cornelis Marinus van Gogh, an art dealer in The Hague.

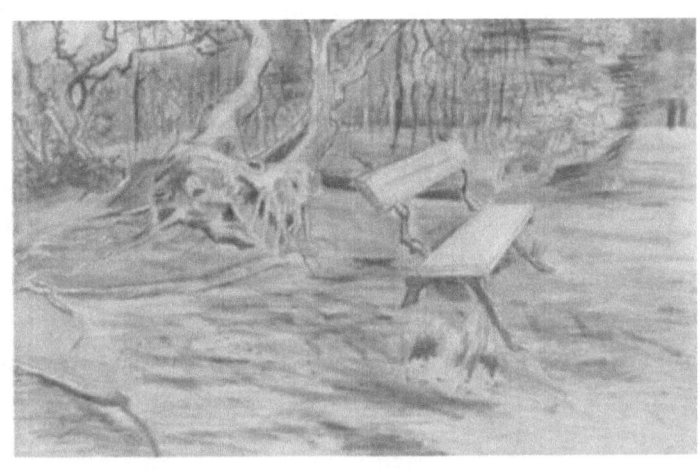

The Bench

1882, Pencil, pen and brown ink on paper, 27.9 x 36.1 cm, Private Collection

The current drawing was completed around the same time as two watercolors which van Gogh sent to his brother Theo in a September 1882 letter. He wrote, "As you will remember, when you were here, you spoke about my someday trying to send you a little drawing of a 'salable' nature. However, you must excuse my not knowing exactly when a drawing is, and when it is not, that kind. I used to think I knew, but now perceive daily that I am mistaken. Well, I hope this little bench, though perhaps not yet salable, will show you that I am not averse to choosing subjects sometimes which are pleasant or attractive and, as such, will find buyers sooner than things of a more gloomy nature". The watercolors he sent, one of four people on a bench, and one of a nearby wood, were signed, an indication that van Gogh considered them finished, and hoped that Theo might indeed sell them.

The Bench belongs to a small group of the 'pleasant or attractive' subjects that van Gogh spoke of choosing to render. These drawings and watercolors all focus on figures walking or resting on a bench in a similar Hague wood. The current drawing is the only example from the series in which an empty bench and trees replace the figures as the work's primary subjects. The presence of other people is suggested only by two small outlines in the upper right corner of the nearly horizonless composition. Van Gogh's quick pencil confidently delineates the wonderfully knotted, gnarled and exposed roots of the two central trees. Although the monumental roots still anchor the trees to the earth, it seems evident that they will soon fall, and be cut into planks, possibly to build a bench similar to the adjacent one.

Largely self-taught, van Gogh learned from illustrations in art publications, from prints, from his voracious reading, and from his extraordinary visual memory. Earlier in 1882, the artist had designed a perspective frame modeled on a similar device he saw in an Albrecht Dürer print. He relied on the instrument to help in his study of 'good drawing' and perspective. Here, in his dramatic foreshortening of the bench, treatment of its receding perspective lines, and in the echoes of the bench in the receding trunks of the falling trees, van Gogh demonstrated his attention to such lessons. Neither a wholly spontaneous observation of nature, nor an overly wrought composition, The Bench is among the rare, truly successful and original drawings from the artist's very early career in The Hague.

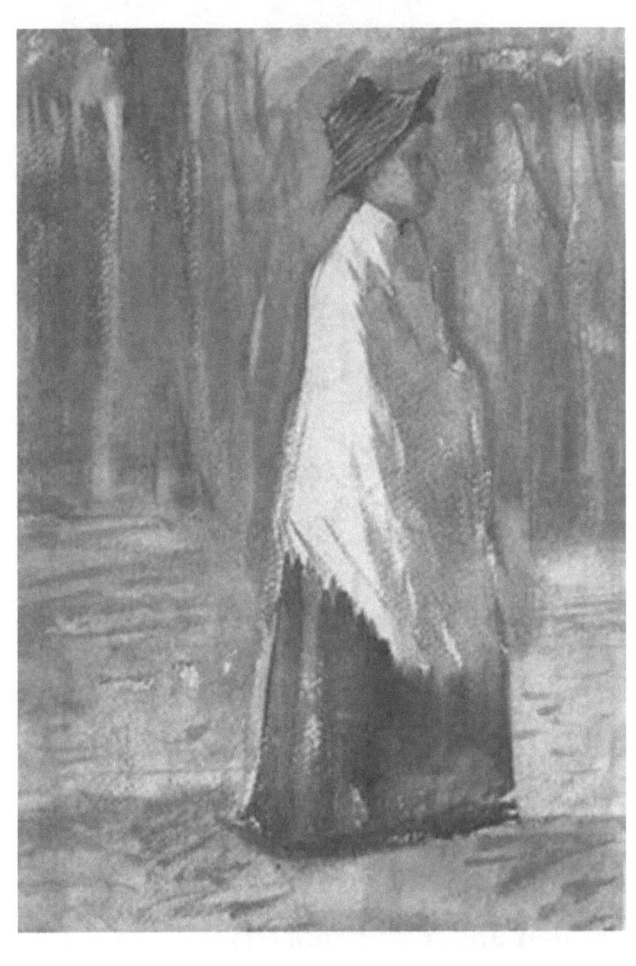

Woman with White Shawl in a Wood

1882, Watercolor, Teheran, Collection A. Farmanformaian

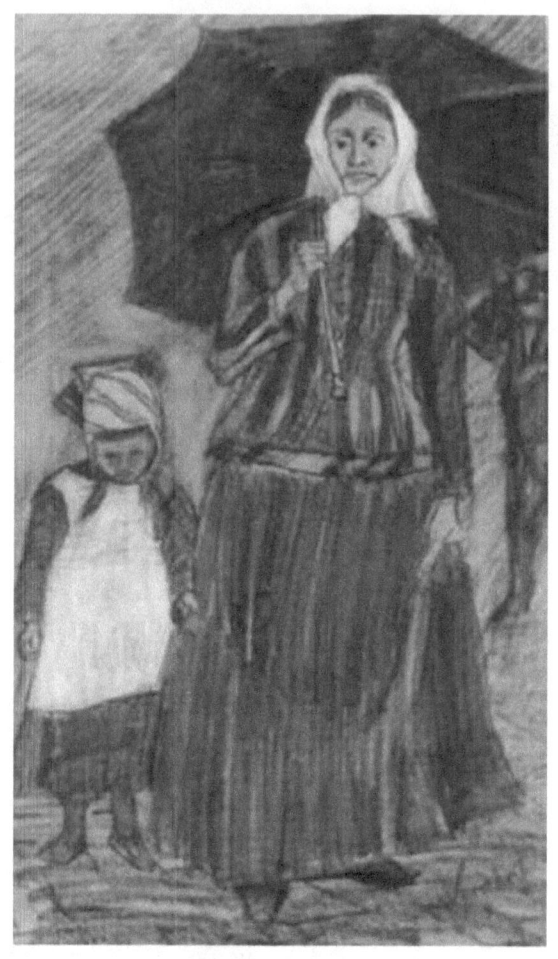

Sien under an Umbrella with a Girl

1882, Pencil heightened with white Chalk on tan paper laid down on paper, 45 x 25.5 cm, Private Collection

By November 1881 van Gogh's relationship with his parents, with whom he had been staying in Etten since April, had greatly deteriorated because of the artist's unwelcome romantic advances towards his cousin Kee Vos. Van Gogh moved to The Hague in January 1882,

where he had previously studied with Anton Mauve, his mentor during this early period, and took a room on the outskirts of town only ten minutes from Mauve.

Although van Gogh was happy at finally having his own place in which to paint, he found it difficult to find models who would pose for him. On 22 January he wrote to his brother Theo, "I have already had various models, but they are either too expensive, or they find it too far to come, or they complain about it and cannot come back on a regular basis". However, in March he writes "This one is a new model, although I have made superficial drawings of her before. Or rather, there is more than one model, as I have already had three people from the same house, a woman about forty-five, who looks just like a figure by Edouard Frre, and also her daughter, thirty or thereabouts, and a younger child of ten or eleven. They are poor people, and I must say their willingness is boundless". The mother was Maria Hoornik, her daughter was Clasina Hoornik, called "Sien", and the child was her younger sister, also named Maria.

Van Gogh began living with Sien sometime before May 1882, when he revealed this fact to Theo. Sien was in reality a prostitute, the unwed mother of a five-year-old daughter, and expecting another child. Although Theo admonished the artist for this improper liaison, and was intensely worried that Vincent might marry Sien, he continued to send money that enabled the artist to pay the rent on his living quarters. This support came at a crucial time: van Gogh had recently fallen out with Mauve, and he seemed beset with difficulties on all sides.

Despite these trying conditions the artist's work progressed apace. The present drawing shows Sien, and is probably among the first that the artist made of her. The young girl cannot be positively identified -- she is too small to be Sien's ten-year-old sister, and it is unclear if she is Sien's daughter (also named Maria) or another child van Gogh engaged to pose for him (the artist often drew figures in the streets). The handling of pencil and white Chalk displays the growing confidence the artist placed in his firm and emphatic line. The diagonal lines in the upper corners serve to shade the background and may represent a driving rain against which Sien holds up her umbrella. Whether he depicts a single figure, or a pair as he does here, Van Gogh's involvement in the daily lives of his subjects is always apparent, and the aggressive hatching and overall lack of refinement in his handling of the media seems well-suited to his depictions of these hardworking poor folk, whose lives are a simple and passionate metaphor for the artist's own struggle.

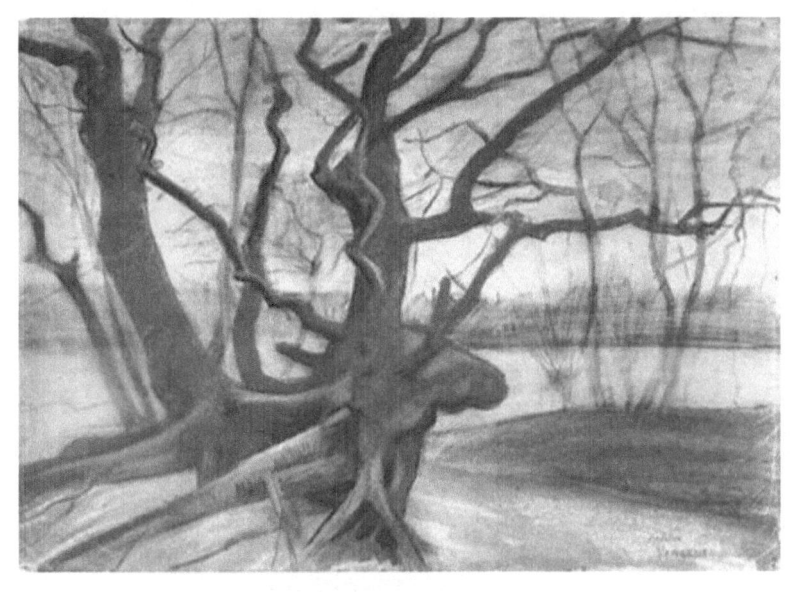

Tree Roots in a Sandy Ground ("Les Racines")

1882, Watercolor, Otterlo, Kroller-Muller Museum

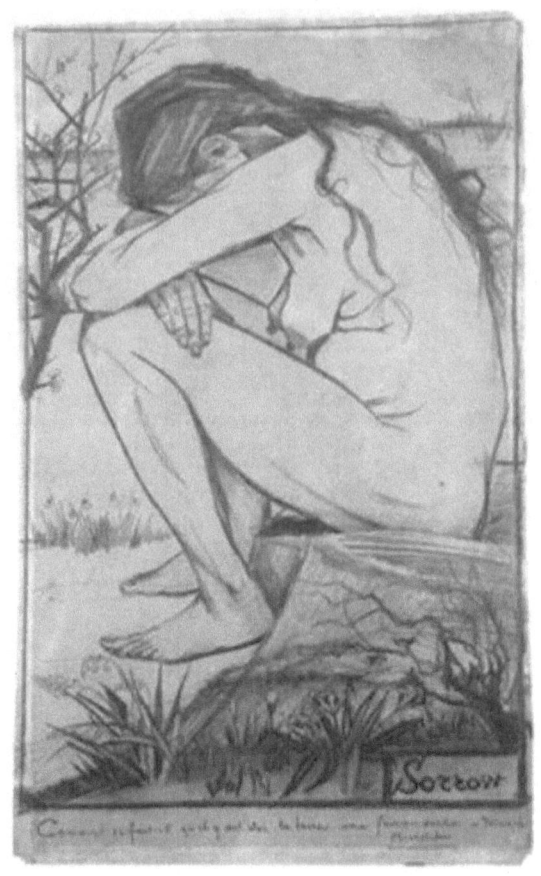

Sorrow

1882, Pencil and wash on paper laid down on thin card, 46.7 x 30.2 cm, Private Collection

'In my opinion... the best figure I have drawn yet... It is not the study from the model, and yet it is directly after the model'

So wrote Vincent van Gogh wrote to his brother Theo, describing Sorrow after its execution in The Hague in April 1882. This was the first picture that Vincent sent

his brother from the Hague. This picture, for which the model was the prostitute Sien, who had become Van Gogh's lover, was basically his first nude. Experimentally, he has chosen this opportunity to allow a simple, calligraphic line to convey an image: 'Last summer when you showed me Millet's large woodcut 'The Shepherdess', I thought, How much can be done with one single line. Of course I don't pretend to be able to express as much as Millet in a single contour. But I tried to put some sentiment into this figure'.

The Millet woodcut, of which Van Gogh owned a flawed print, depicted a woman who appeared forlorn. Van Gogh has taken this image a step further, making an essentially Symbolist picture in which Sorrow itself has been invoked, prefiguring his later distinctive expressionism.

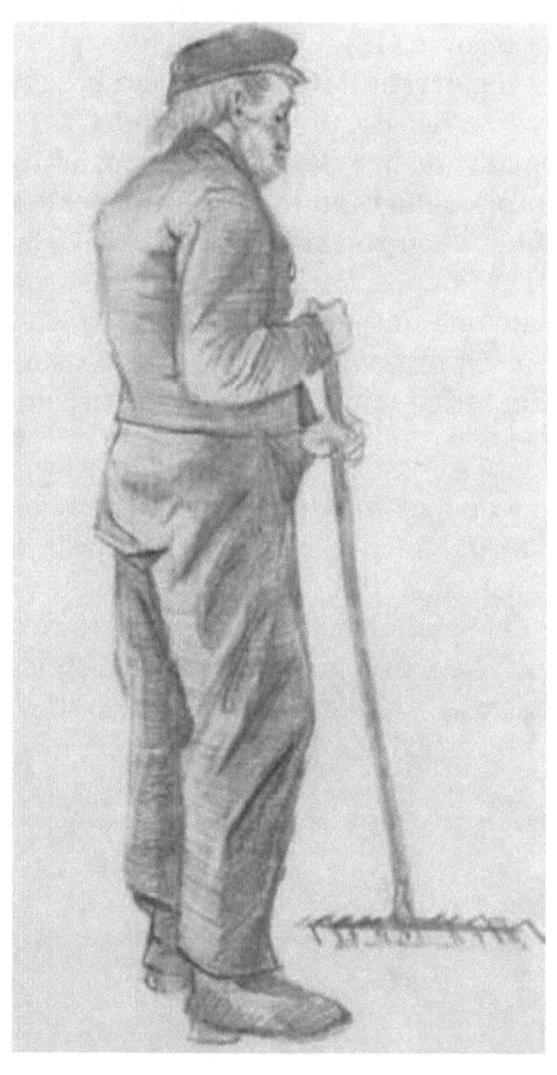

Almshouse man (Mr. Adrianus Zuyderland) raking

1882, Pencil on wove watercolor paper, 43.8 x 22.3 cm, Private Collection

The person with the remarkable whiskers is the one Van Gogh represented most in his Hague drawings. He has been identified as then 72-year-old Adrianus

Zuyderland, a resident of the Dutch Reformed Almshouse in The Hague, an old people's home. Van Gogh loosely referred to him as 'weesman', 'orphan man', and that is the name under which he entered art history. These partners less people were obliged to wear black overcoats and top hats and wore a number on their clothing; Zuyderland was nr. 199. The men were allowed to go out of the Almshouse only three days a week, apart from the Christian holidays. Van Gogh paid him a few quarters for posing; an extra earning that Mr. Zuyderland had to report to the supervisors.

On this large drawing Adrianus Zuyderland is represented at full length, as if engaged in action. The upright posture gives the drawing a rather dignified and monumental effect. This firmness is enhanced by the oval hatching that encircles the figure and follows the perspective. Van Gogh chose to represent the man in lost profile, with his eyes cast down, as if he were absorbed in his action.

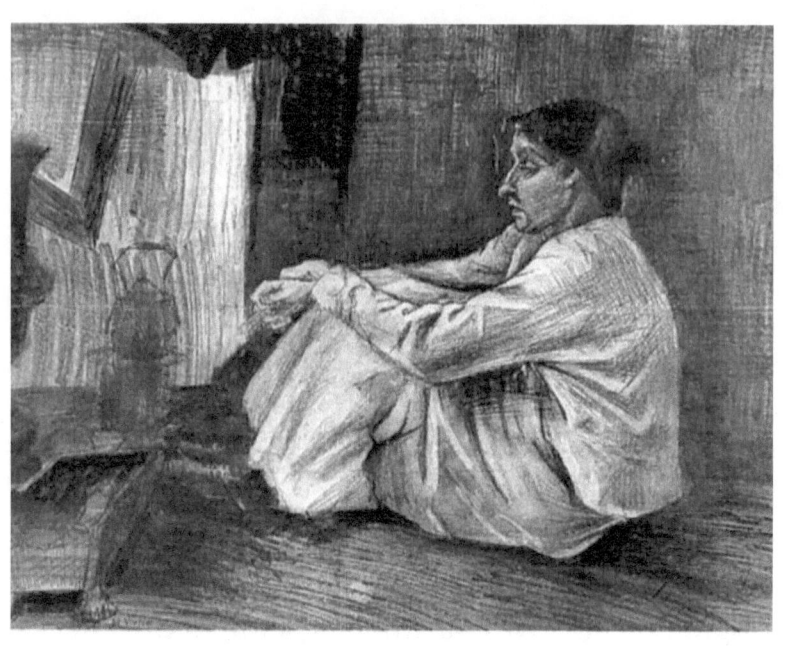

Sien with Cigar Sitting on the Floor near Stove

1882, Pencil

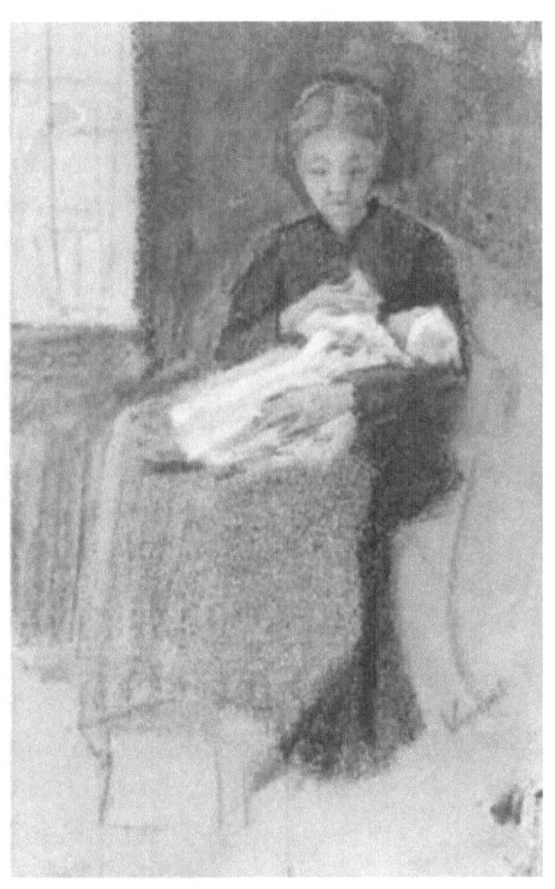

Sien Nursing Baby

1882, Gouache, watercolor and black Chalk on paper laid down on paper, 48 x 38.5 cm, Private Collection

On 22 January 1882 van Gogh wrote to his brother Théo, "I have already had various models, but they are either too expensive, or they find it too far to come, or they complain about it and cannot come back on a regular basis". However, in March he wrote again, "This one is a new model, although I have made superficial drawings of her before. Or rather, there is

more than one model, as I have already had three people from the same house, a woman about forty-five, who looks just like a figure by Edouard Frère, and also her daughter, thirty or thereabouts, and a younger child of ten or eleven. They are poor people, and I must say their willingness is boundless" .The older woman was Maria Hoornik, the younger was her daughter Clasina Maria Hoornik, called "Sien", and the child was Sien's younger sister, also named Maria.

Later in the same letter van Gogh noted that Sien "is not handsome but her figure is very graceful and has some charm for me." He was attracted to her, feelings which were no doubt partly motivated by his evangelical compassion for her condition: Sien was a prostitute and the unwed mother of a five-year old daughter (also named Maria, who often stayed with her grandmother), and was expecting another child, whose father had deserted her. "I took that woman on as a model and have worked with her all winter. I couldn't pay her a model's full daily wages, but I paid her rent all the same and this far thank God I have been able to save her and her child from hunger and cold by sharing my own bread with her". They began living together and moved to a larger apartment some time before May 1882, when the artist revealed their relationship to his brother. Théo admonished Vincent for this improper liaison, and had good reason to worry that Vincent might marry Sien out of charity. He nevertheless continued to send money that enabled the artist to pay the rent on his living quarters. This unwavering support came a crucial time: van Gogh had recently fallen out with Mauve, he now had another mouth to feed, and he seemed beset with difficulties on all sides.

However, with the regular availability of a model his work at drawing figures progressed. Sien was subject to fits of melancholy and bad temper, and was occasionally difficult, but this was not dissimilar from van Gogh's own temperamental behavior, and they understood each other. "If I sometimes get angry because something is not going well and I fly into a rage" he wrote the painter Anthon van Rappard, "she does not take it as an insult as most people do, but gets me to calm down and start all over again. And as regards the tedious search for this or that position or pose, she has patience for that. And so I think she is a darling."

Sien gave birth to her son Willem Hoornik on 2 July 1882 in a hospital in Leiden. While she was away, van Gogh moved to better quarters on the attic floor of the house next door, which consisted of a living room adjoining a sizable studio space with a large window. He now had a regular family to look after. He relished the domesticity of this new situation; it was to prove to be one of the happiest times in his life. In September the "little man", as van Gogh affectionately called Willem, made his first appearance in the artist's work, in a series of drawings and watercolors that show Sien seated in the apartment's wicker armchair while nursing him. The present work is the only one in this group in which the artist defines the interior setting by using the corner of the window at upper left, and it is the only one that he signed. While in The Hague, van Gogh worked in oils for only brief periods, but he still felt hampered by his awkwardness at painting the figure, and found that he made more rapid progress using watercolor and drawing media.

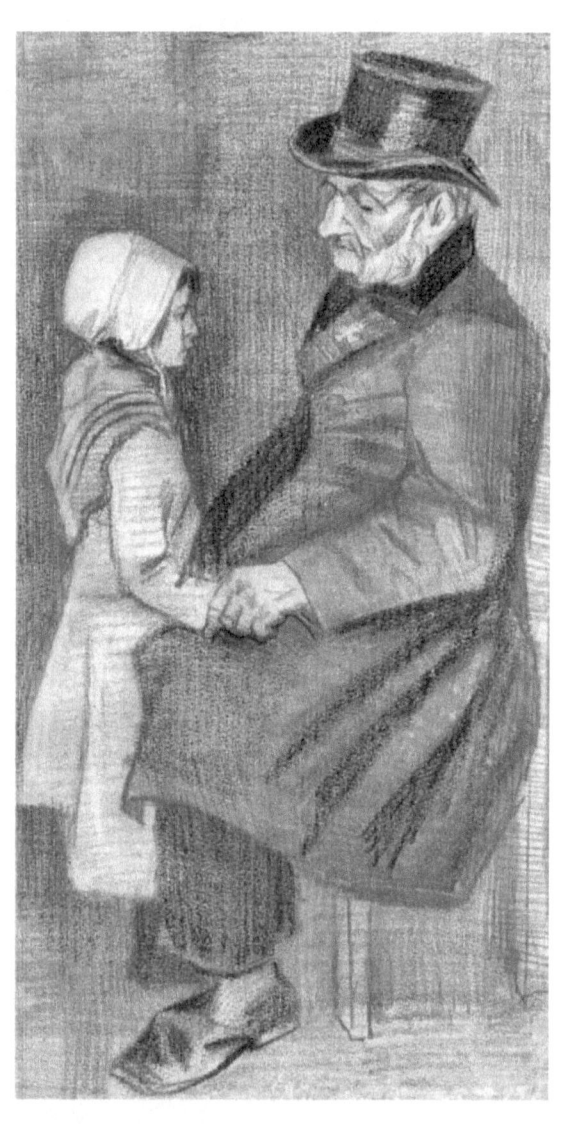

Orphan Man, Sitting with a Girl

1882, Chalk

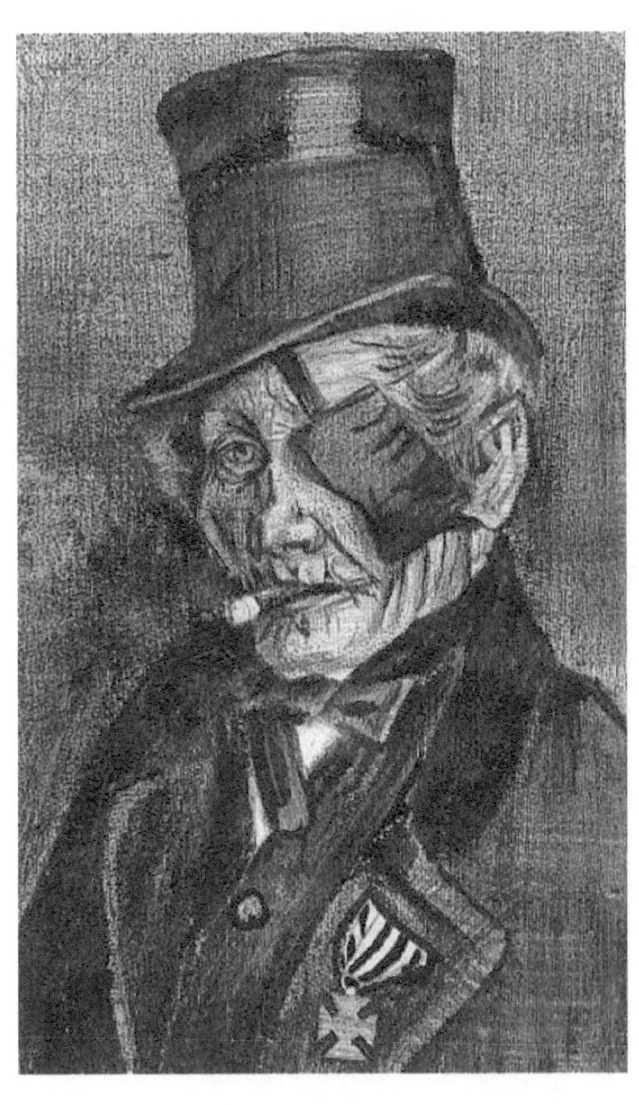

Orphan Man in Sunday Clothes with Eye Bandage

1882, Chalk

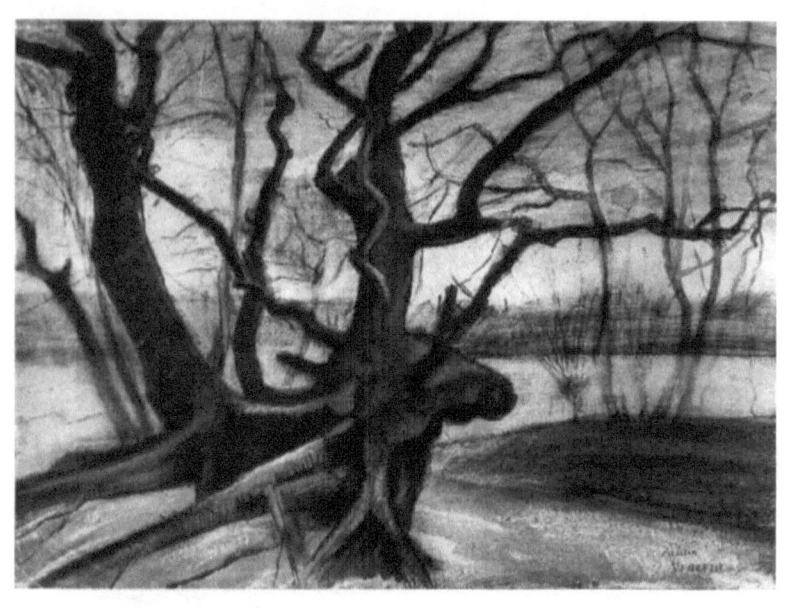

Study of a Tree

1882, Chalk

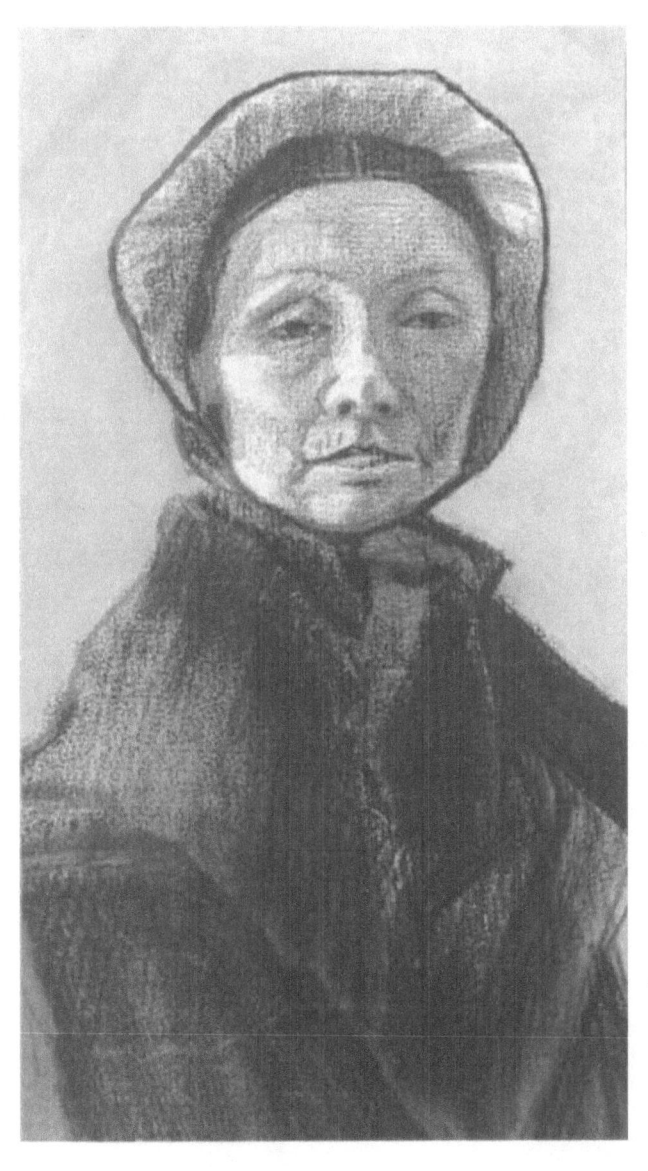

Woman with Dark Cap, Sien's Mother

1882, Chalk

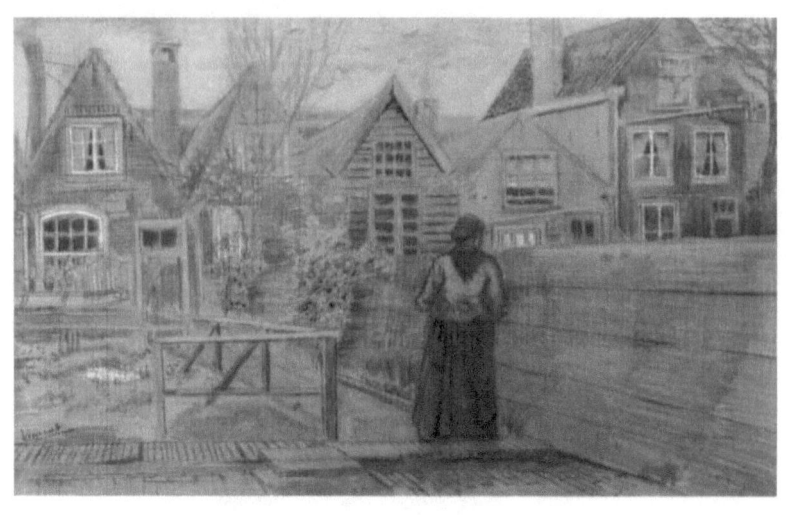

Sien's Mother's House Seen from the Backyard

1882, Pencil, Chalk

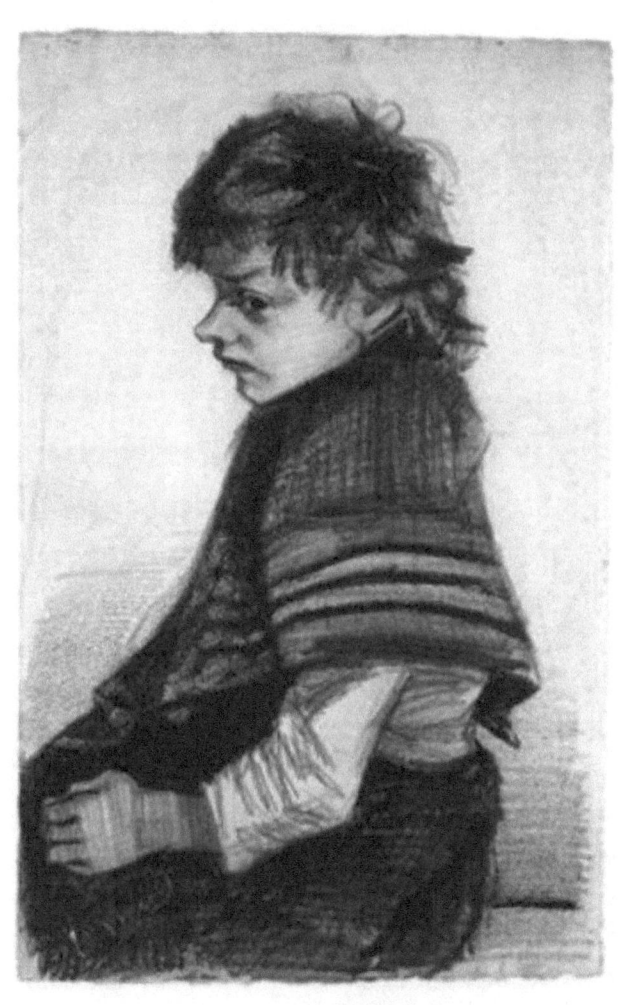

Girl with a Shawl

1882 - 83, Drawing, Pencil, black lithographic crayon, scratched, on watercolour paper, Van Gogh Museum

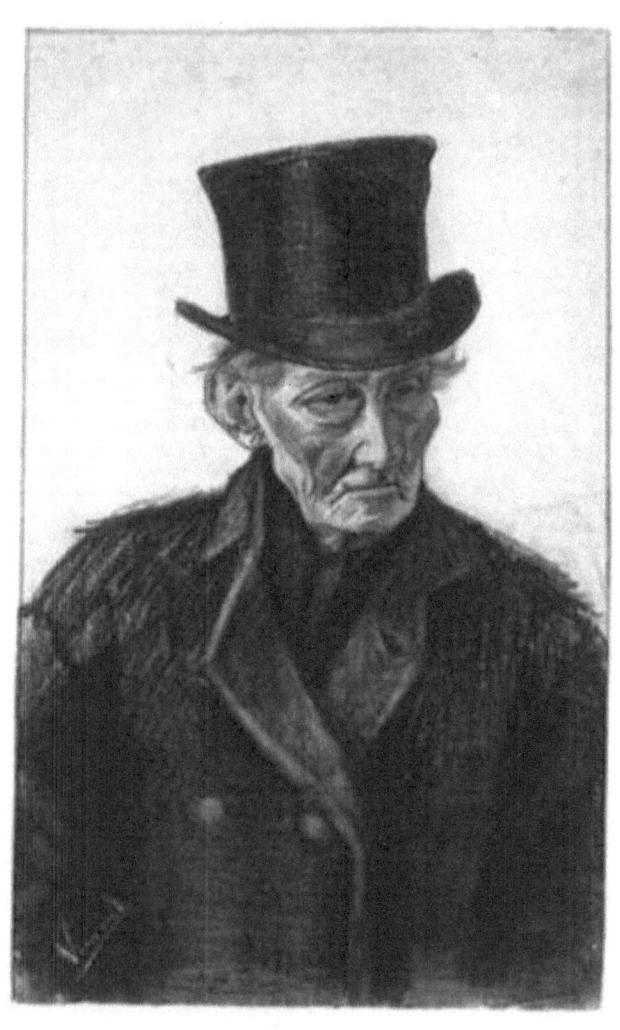

Old Man with a Top Hat

1882 - 83, Pencil, black lithographic crayon, pen and brush in brown ink, scratched on watercolour paper, Van Gogh Museum

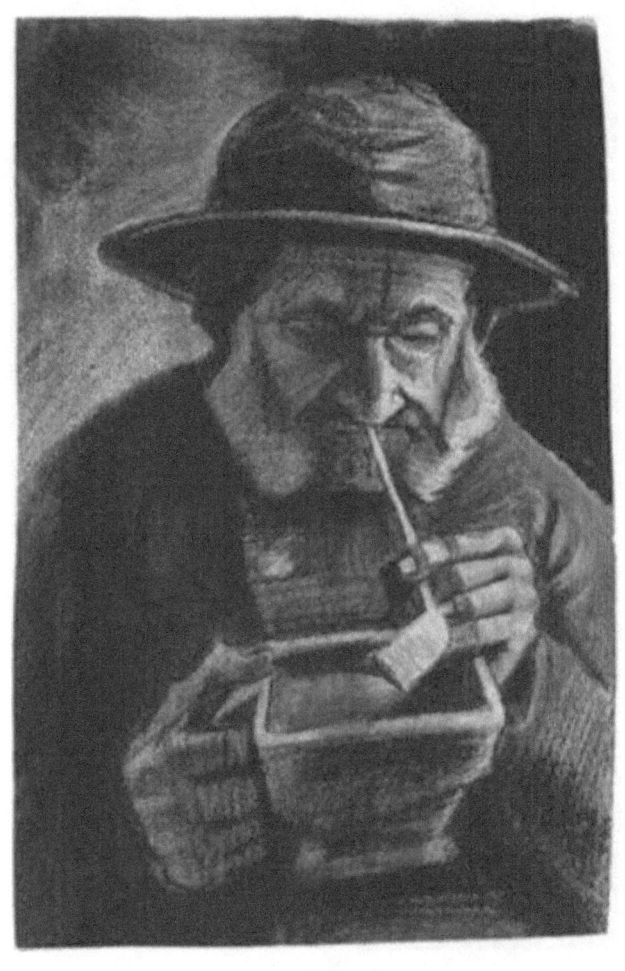

Fisherman with Sou'wester, Pipe and Coal-pan

1883, Drawing, Pencil, black lithographic crayon, grey and pink watercolour, on watercolour on paper, Van Gogh Museum

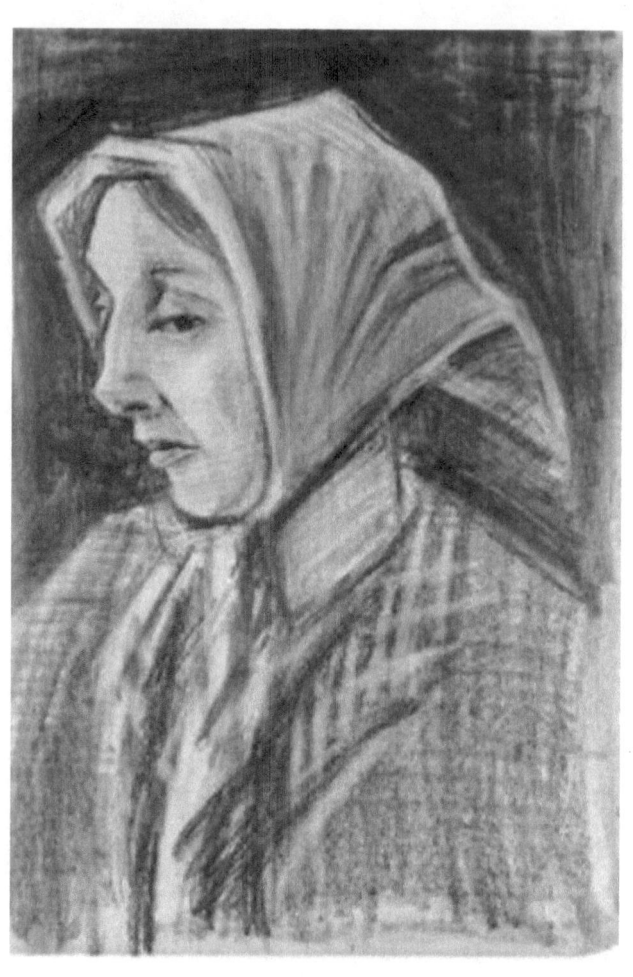

Sien: facing left

1883, Pencil and black mountain Chalk on paper, 28.6 x 18.1 cm, Private Collection

This intimate drawing by van Gogh is a striking portrait of melancholy. Sien: facing left dates from March 1883, when the artist was living in The Hague.

He had been living there since 1881, when a row with his parents had precipitated his departure from them. During his highly productive time in The Hague, van Gogh frequently drew and sketched life on the streets, his religious fervor prompting him to embrace and celebrate the poor and needy. Soup kitchens, paupers and prostitutes filled his work. These were, however, the people that van Gogh loved, feeling that there was a certain solidarity and gypsy charm to them and their way of life. One of his main subjects at the time was Sien Hoornik, an ex-prostitute who at first modeled for van Gogh and later moved in with him, and who appears to be the model here. Taking Sien in was another example of van Gogh's inexhaustible charity and his strong desire to understand and relieve poverty and desperation. Her gaunt and forlorn expression perfectly represented the kind of political and artistic truth and vision that van Gogh sought to capture in his works, the gritty sense of real life.

In order to capture these scenes, van Gogh often resorted to black and white, exploring the potentials of extreme chiaroscuro that this afforded. Writing to his brother about his experimentation with various media, he said, 'Do you remember that last summer you brought me pieces of mountain crayon? I tried to work with it at the time, but it didn't work well. So a few pieces were left, which I picked up the other day; enclosed you'll find a scratch done with it; you see it is a peculiar, warm black'. This rediscovery led to a prolific output of crayon pictures, including Sien: facing left. Indeed, he loved the Chalk so much that he repeatedly begged his brother for more, and soon afterwards wrote ecstatically about it:

"There is a soul and life in that crayon - I think conté pencil is dead. Two violins may look the same on the outside, but in playing them, one sometimes finds a beautiful tone in one, and not in the other."

In Sien: facing left, van Gogh has vigorously rendered the woman's face, leaving it much lighter and more detailed than the rest. Indeed, the body has in part been shaded with heavy vertical and horizontal strokes, making the face and its expression the focal point of the picture with mere gleams of light left on her clothes.

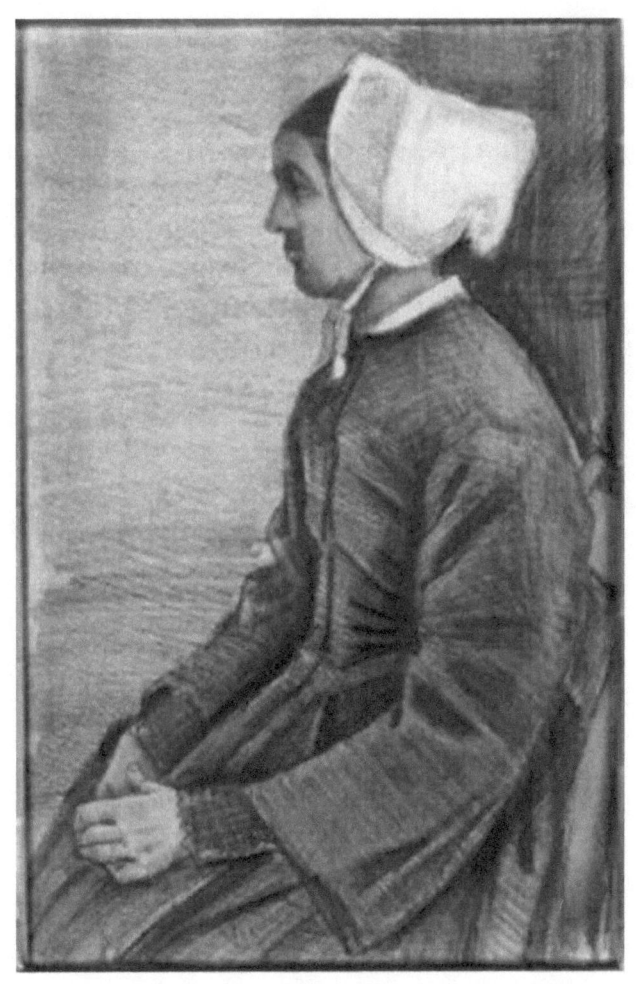

Woman with White Cap, Half-length

*1883, Watercolor and pencil on paper, 48.2 x 30.4 cm,
Private Collection*

The present work was drawn while van Gogh was residing on the outskirts of The Hague. He was living with Sien Hoornik who had a daughter Maria about six years old, and gave birth to a second child in July 1882.

While Vincent has not married to Sien, and neither child was his, he was deeply in love with her.

The model in the present drawing is probably Sien. She, her mother, younger sister and her own two children were van Gogh's most frequent figure subjects during his stay in the The Hague. Since his arrival more than a year before, his figures acquired a more monumental aspect, in which the artist carefully balances light and shade, volume and space.

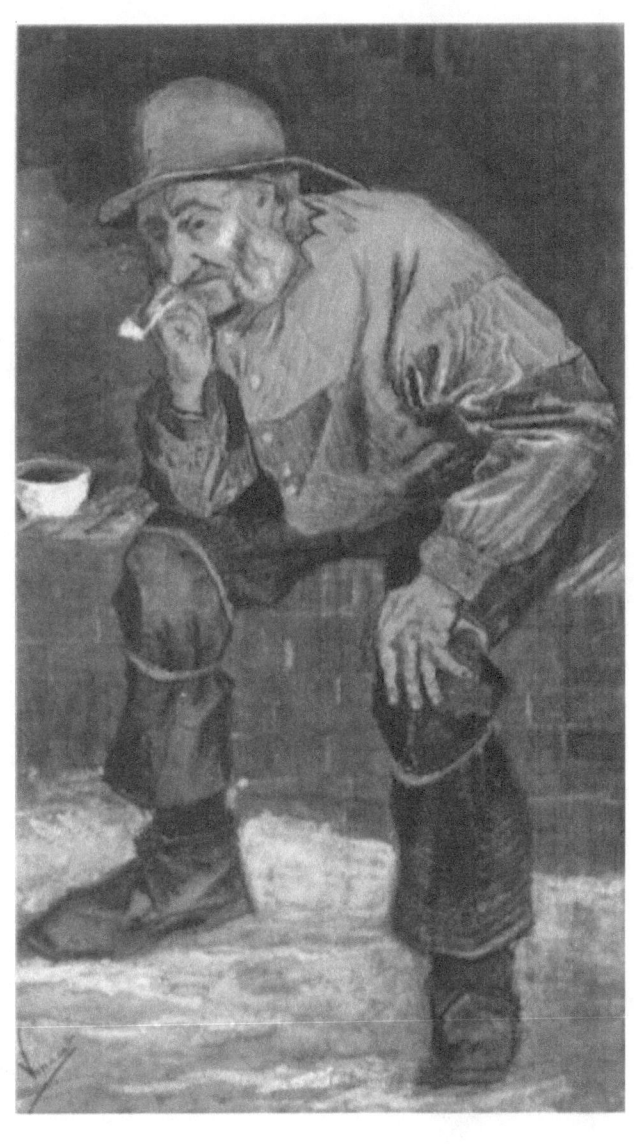

Fisherman with Sou'wester, Sitting with Pipe

1883, Chalk

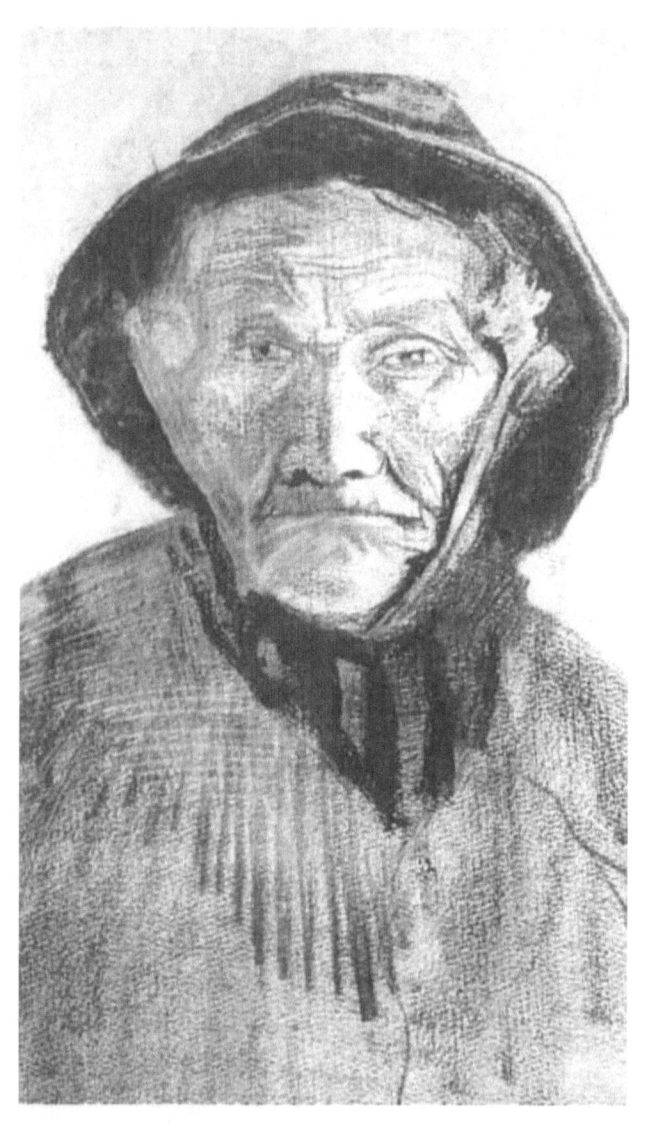

Fisherman with Sou'wester

1883, Chalk

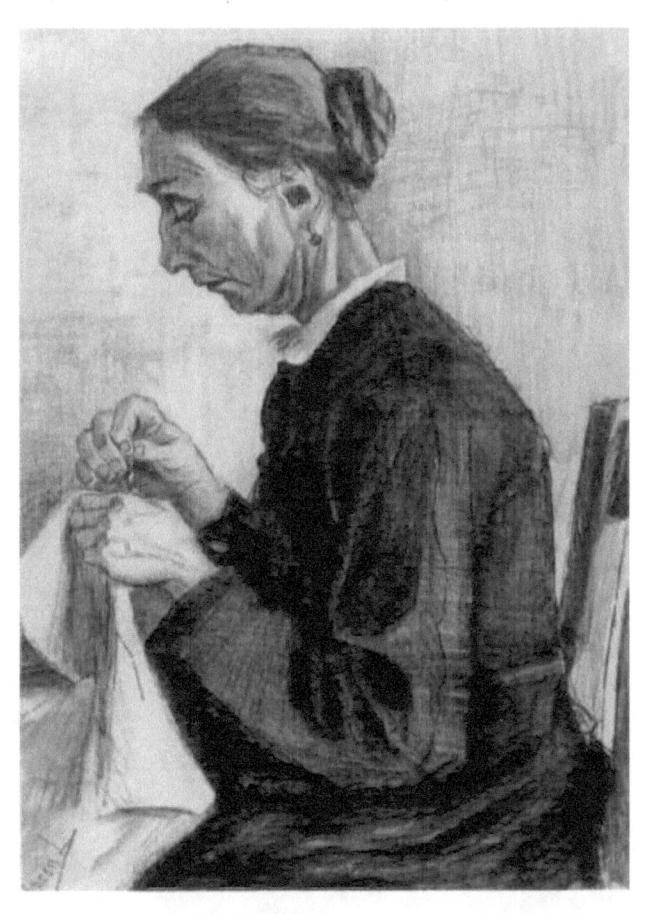

Sien, Sewing, Half-Figure

1883, Chalk

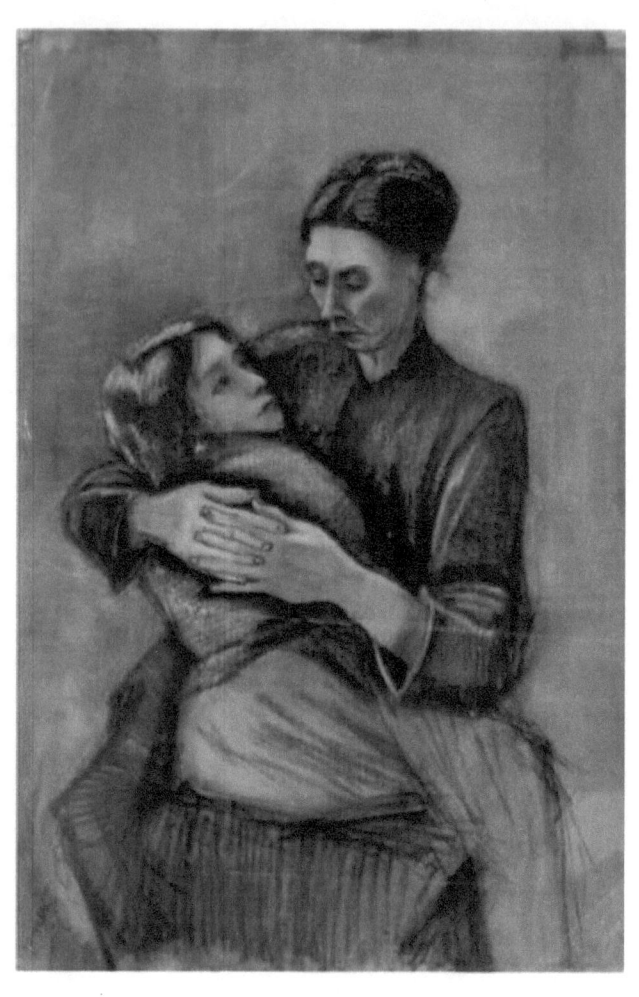

Woman with a Child on Her Lap

1883, Chalk

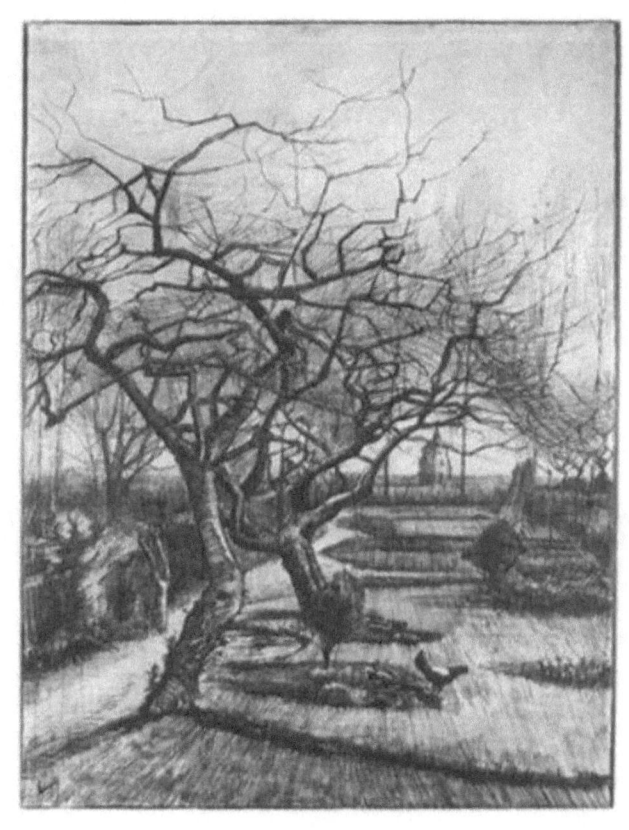

Parsonage Garden

1884, Drawing, Pen, heightened with white, Szepmuveszeti Museum, Budapest, Hungary

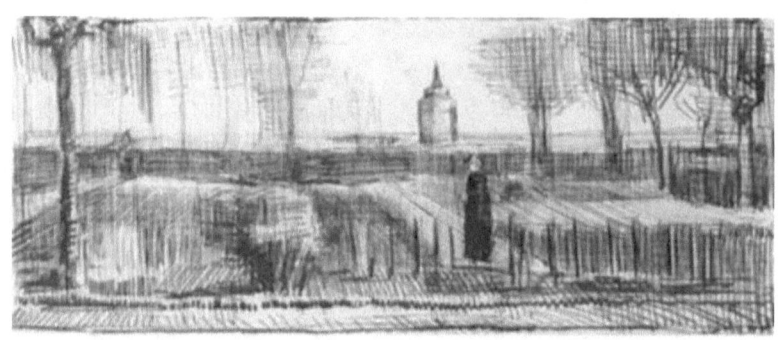

Pastorie tuin - Parsonage Garden

1884, Black ink on paper, 9 x 21 cm, Private Collection

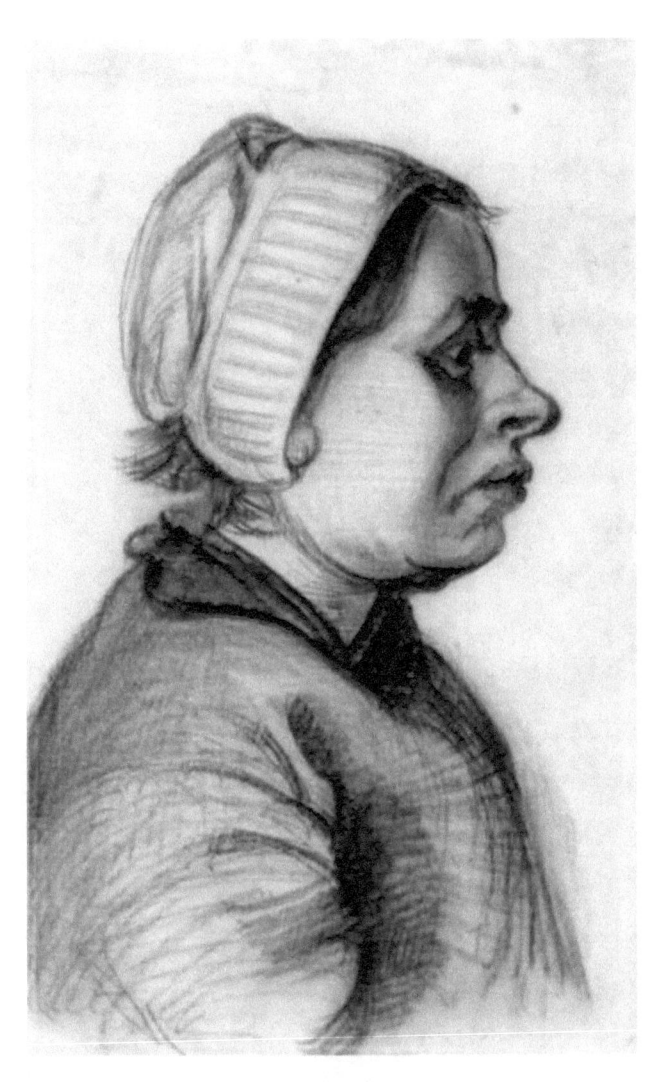

Head of a Woman

1884, Chalk

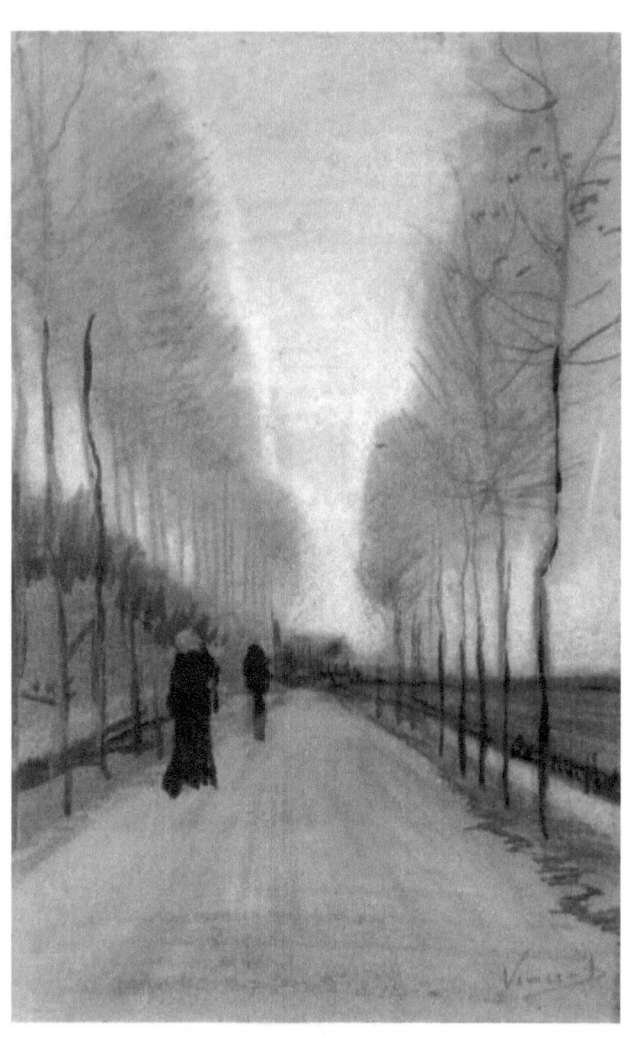

Alley Bordered by Trees

1884, Chalk

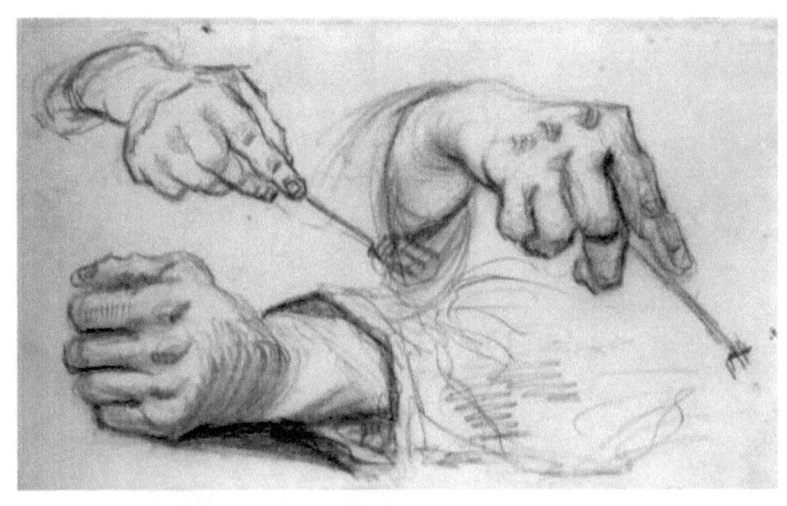

Three Hands, Two Holding Forks

1884, Chalk

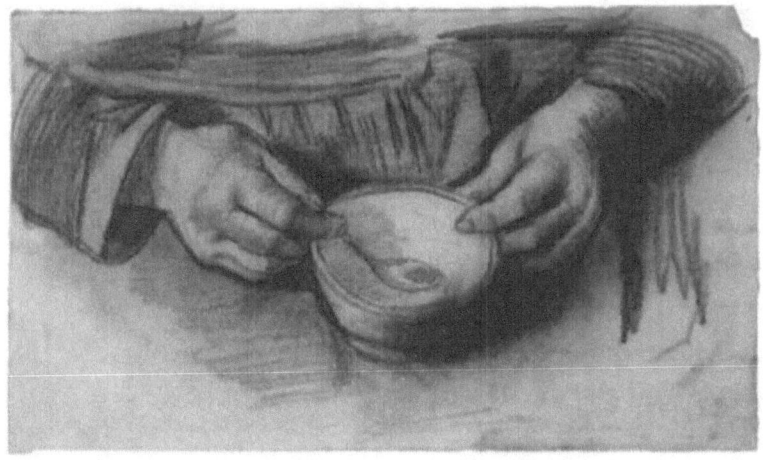

Lap with Hands and a Bowl

1884 - 85, Drawing, Black Chalk on laid paper, Van Gogh Museum

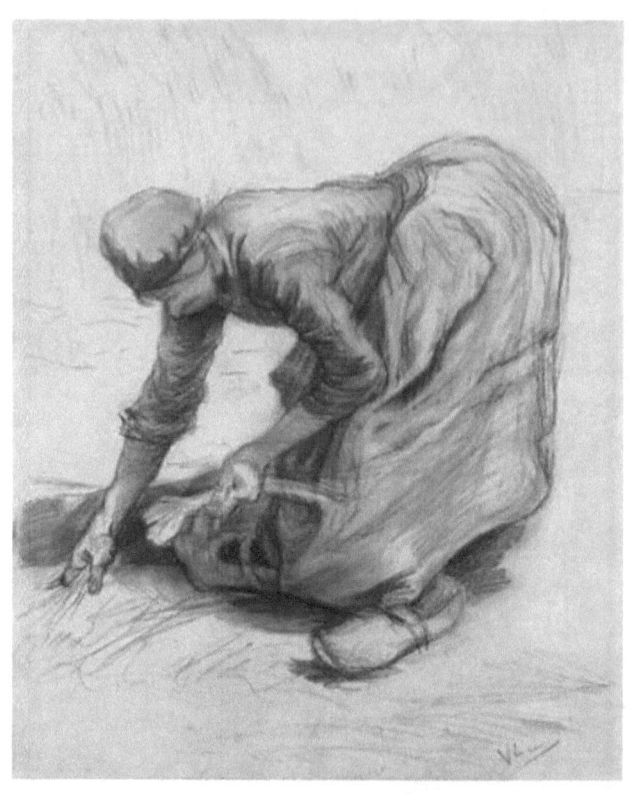

Paysanne Woman

1885, Black Chalk, grey wash heightened with white on paper, 53.3 x 42.5 cm, Private Collection

It was during 1885, the year that he painted his Potato Eaters that the art of Vincent van Gogh truly came to fruition. The lessons he had learned in art, both as an autodidact and later in classes, matured under the influence of the lessons he had learned in life, both in the city living with Sien, and later after over a year spent amongst the peasants of Neunen. In July that year, he wrote to his brother that, 'I have here before me some figures: a woman with a spade, seen from

behind; another bending to glean the ears of corn; another seen from the front... I have been watching these figures here for more than a year and a half, especially their action, just to catch their character'. Paysanne Woman, or certainly one of its sister-works, executed between July and August of that year, may have been the study to which he referred. Millet was the most famous artist to celebrate the life of the peasant in his art, and it was still considered scandalous. Van Gogh, though, held Millet in a position of great reverence - indeed, it was by tracing and copying prints and photographs of his work that Van Gogh had initially learned to draw. Paysanne Woman shows the older master's influence both in the subject matter, and the vigorous style of execution, which not only betrays, but flaunts the fact that this was no studio work, but was produced literally in the field, capturing as quickly as possible the laborer's movements.

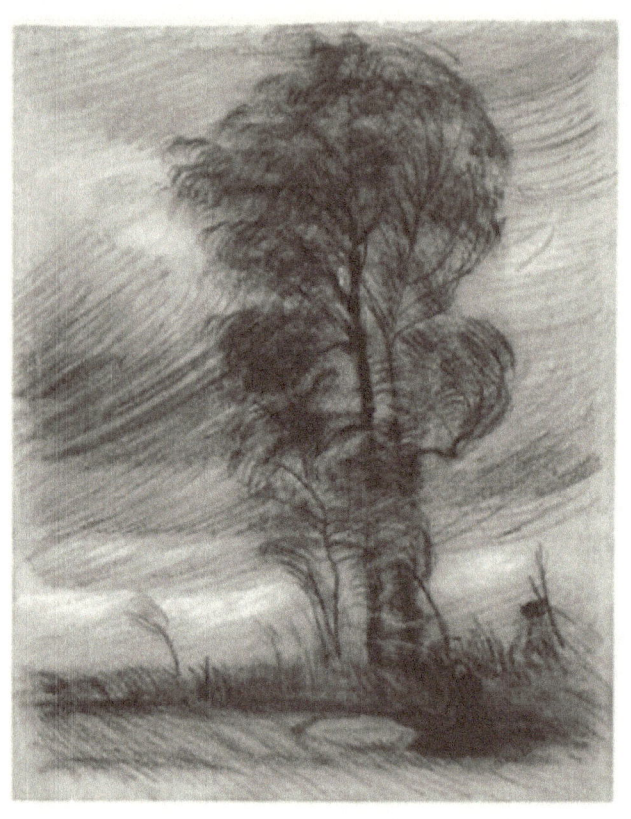

Landscape in Stormy Weather

1885, Drawing, Black Chalk, heightened with white Chalk, on light grey-blue laid paper, Van Gogh Museum

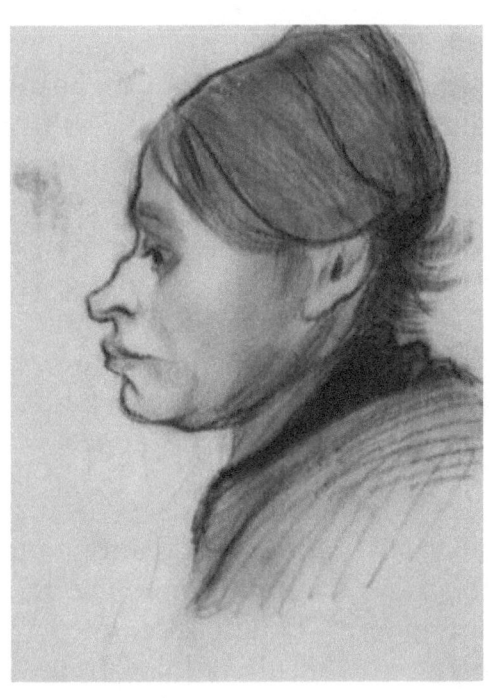

Head of a Peasant Woman: Left Profile

1885, Charcoal on paper, 34.6 x 21 cm, Private Collection

Van Gogh drew this Head of a Peasant Woman: Left Profile in the Dutch village of Nuenen in February or March of 1885. Following a course in anatomy and physiognomy at the Académie Royale des Beaux-Arts in Brussels and a period in The Hague, in 1883 the thirty-year-old Van Gogh decided to return home to his parents, who were then living in Nuenen. This decision, given the artist's age and difficult relationship with his father, can be explained by financial necessity and also by Van Gogh's deep-seated desire--induced by a visit to an artists' community in northern France in 1879-1880 and by a fervent passion for the novels of the French Naturalists--to become a painter of peasant life.

In letters to his brother dated mid-December 1884, Van Gogh reveals his decision to paint fifty heads of peasants inspired by illustrations of "The Legal World" by Paul Renouard that had appeared that year in Paris Illustré. In March 1885, Vincent wrote to Theo again, highlighting the advance of his contemporary head studies in relation to those done in previous years: "I'm making studies, and precisely because of this I can very well conceive of the possibility that a time will come when I, too, will be able to compose readily. And, after all, it is difficult to say where study stops and painting begins".

The importance for Van Gogh of painting peasant heads like Head of a Peasant Woman: Left Profile, is to be understood in terms of his efforts to confront the artists whom he most admired: Jules Breton, Léon Augustin Lhermitte, and, above all Jean-François Millet. These French masters had created solemn depictions of peasant life, and Van Gogh wanted to add to this tradition. As an avid reader of Emile Zola and the Goncourt brothers, however, he was uncompromising about the necessity "to belong to one's own time". In relation to the peasant heads painted in Nuenen, he wrote to Theo: "When I think about Millet or Lhermitte, I find modern art as great as Michelangelo and Rembrandt--the old infinite, the new infinite too--the old genius, the new genius I'm convinced, that in this regard one can believe in the present. The fact that I have a definite view as regards art also means that I know what I want to get in my own work, and that I'll try to get it even if I go under in the attempt".

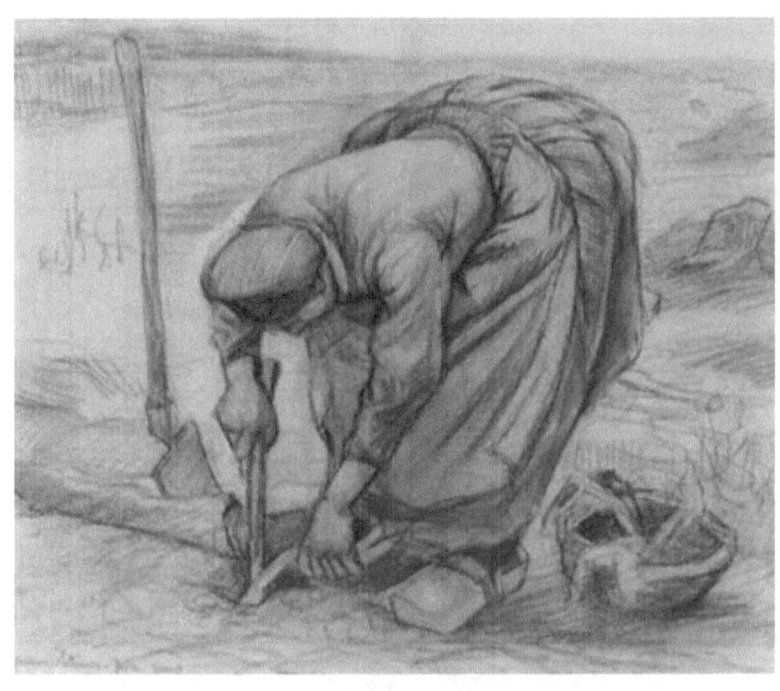

Planting Beets

1885, Charcoal with white heightening on paper, 45 x 52.1 cm, Private Collection

During his time in The Hague, Vincent van Gogh had his first real opportunity to study the human figure from life. This led to a new confidence, which, upon his 1884 move to Nuenen in the southern Netherlands, motivated the painter to pursue more ambitious figural studies. The most significant of his completed multi-figure compositions, The Potato Eaters, was painted in Nuenen from April to May of 1885. When this self-styled "masterwork" was met only with criticism, van Gogh redirected his energies, and practiced depicting more exact representations of the human form in a large series of drawings of rural Nuenen workers. His

approach entailed breaking the body down into basic shapes-circles, ovals, ellipses--and basic volumetric forms.

The present drawing belongs to the approximately fifty surviving sheets from the summer of 1885 during which van Gogh dedicated himself almost entirely to drawing agricultural workers. It is one of two very similar drawings of women planting beets that van Gogh almost certainly completed in the same posing session. Both are annotated at the lower left, "Planteuse de betteraves, juin."

Throughout his career, van Gogh was deeply influenced by Jean-François Millet's portrayal of peasants. In his own work, he hoped to approach what he saw as Millet's allusion to profound truths through forthright realism. By 1880, van Gogh had collected almost fifty of Millet's prints, which he tacked to his walls. His laboring sowers, diggers, peasant women and farmers from 1885 owe a great deal to the study of reproductions of Millet works. In a letter to Theo, he expressed his wish to understand and relate to his subjects as Millet had. He wanted to "paint peasants as if one were one of them, as if one felt and thought as they do".

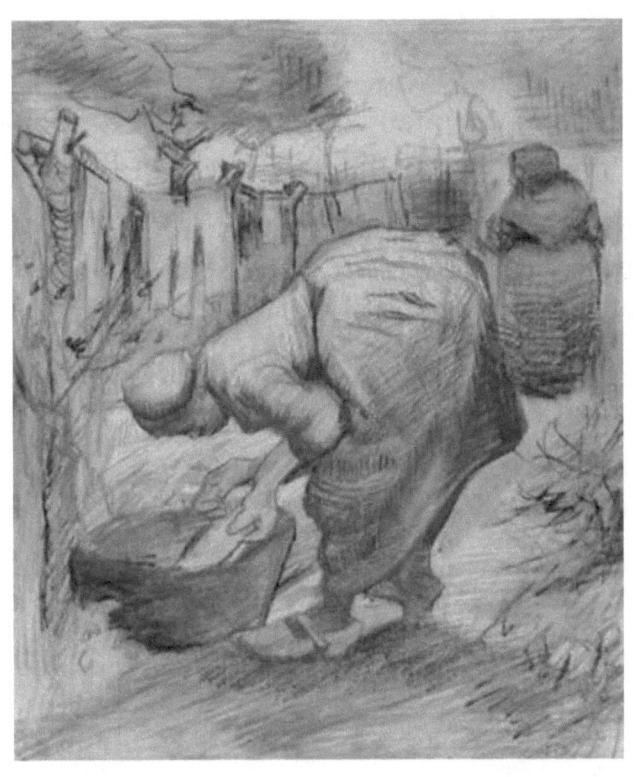

Woman by the Wash Tub in the Garden

1885, black Chalk, pen and ink and pencil on paper, 32 x 26.4 cm, Private Collection

"What is drawing?" Vincent van Gogh asked in an 1882 letter to his brother Theo. "How does one learn it? It is working through an invisible iron wall that seems to stand between what one feels and what one can do. How is one to get through that wall--since pounding at it is of no use? In my opinion one has to undermine that wall, filing through it steadily and patiently." By the early fall of 1885, van Gogh had been successfully "filing through," or shortening the distance between what his sensibility demanded he draw or paint, and

what he was technically able to accomplish. Drawings from Nuenen, like Woman by the washtub, with their exploration of volumetric forms, genre and labor, were an integral part of that learning process.

The present drawing belongs to a small group of peasant women from Van Gogh's 1885 series of Nuenen rural labor.

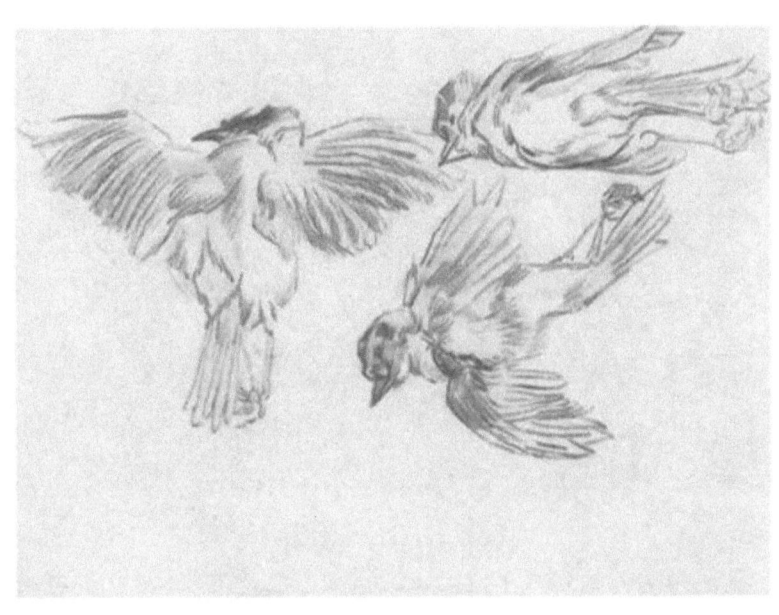

Studies of a Dead Sparrow

1885, Drawing, Black Chalk, Van Gogh Museum

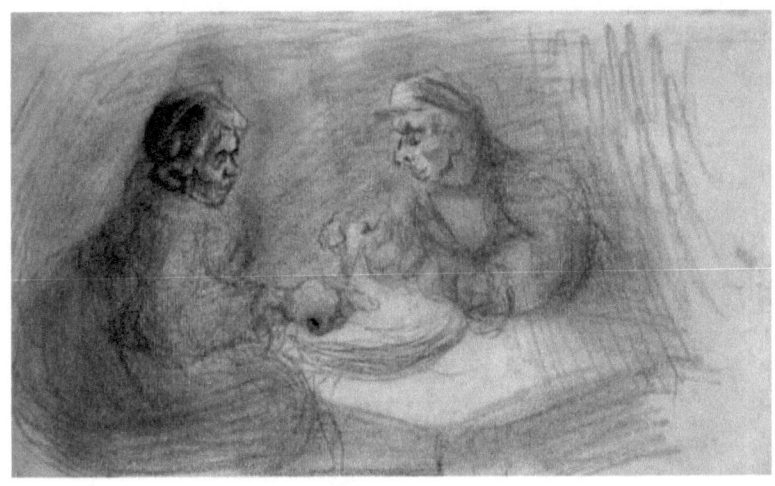

Man and Woman Sharing a Meal

1885, Chalk

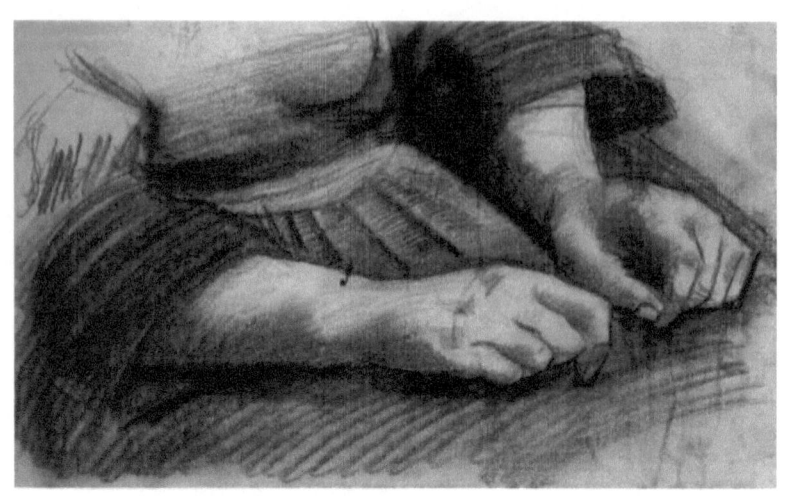

Lap with Hands

1885, Chalk

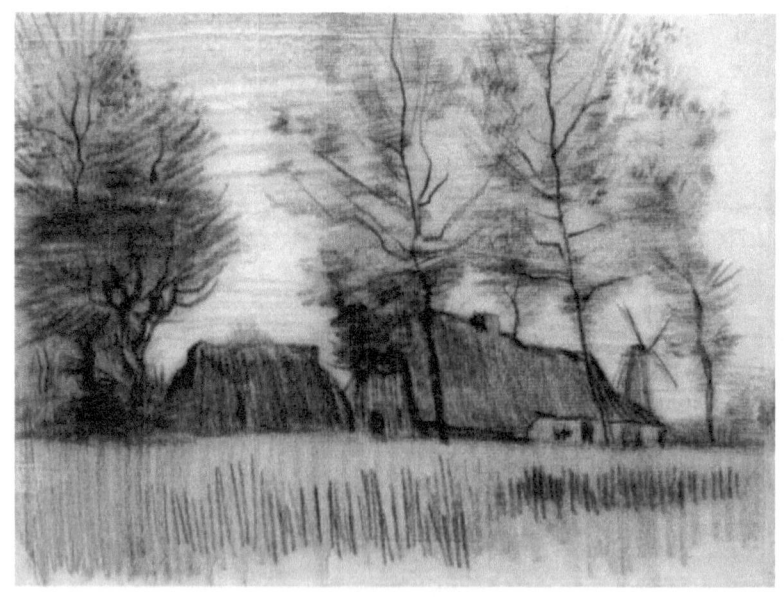

Landscape with Cottages and a Mill

1885, Chalk

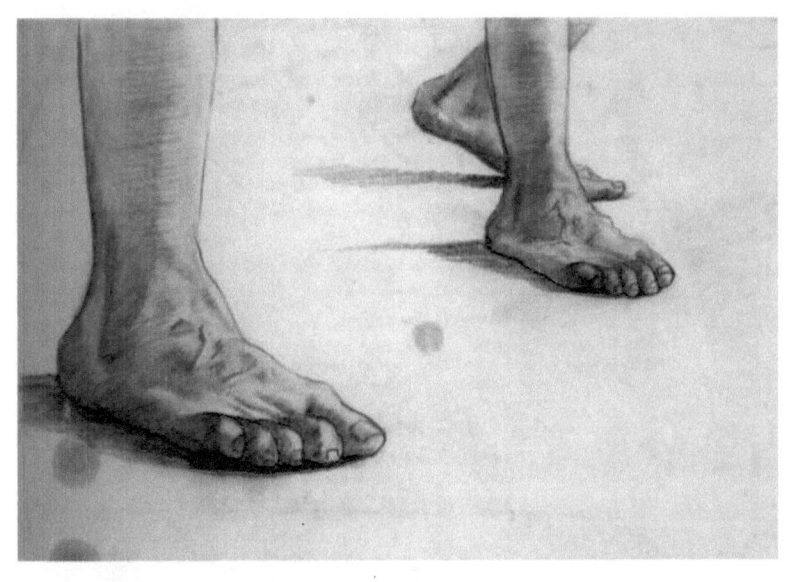

Feet

1885, Chalk

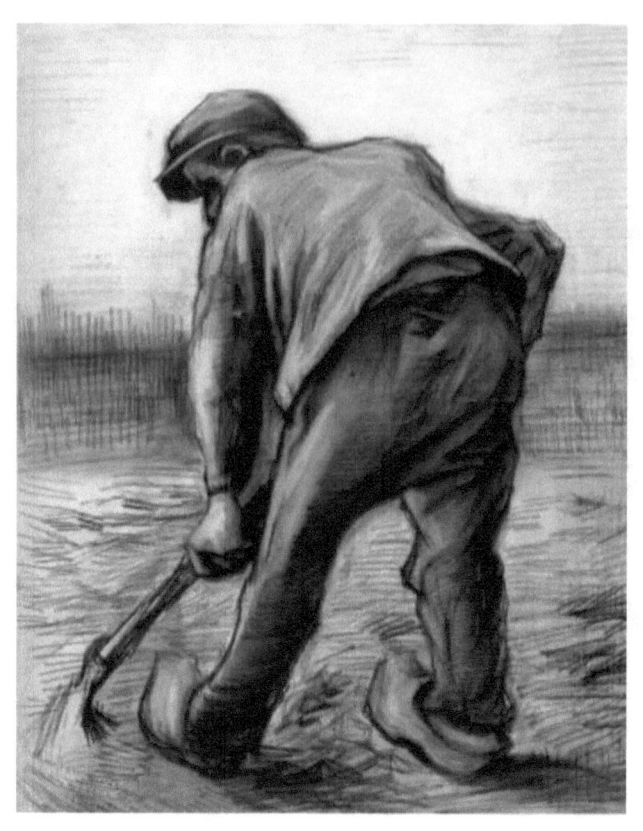

Digger in a Potato Field

1885, Chalk

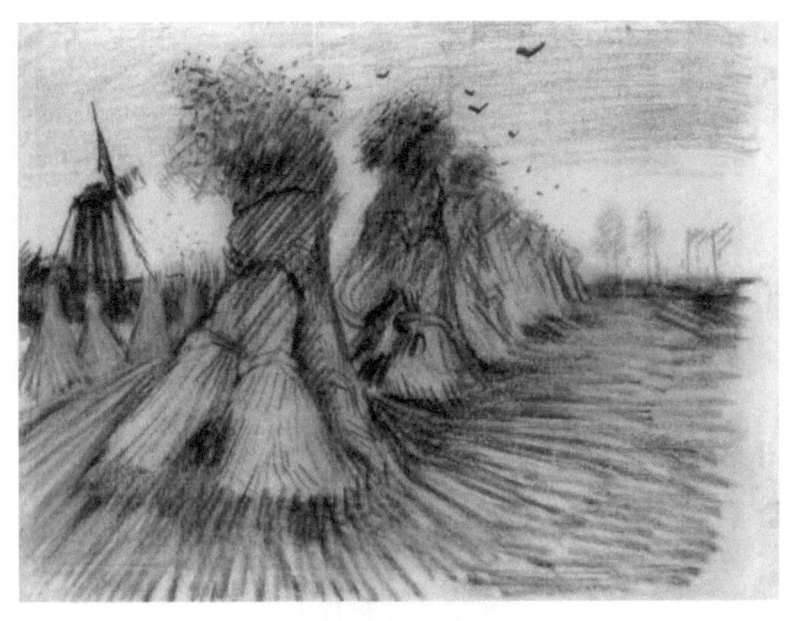

Stooks and a Mill

1885, Chalk

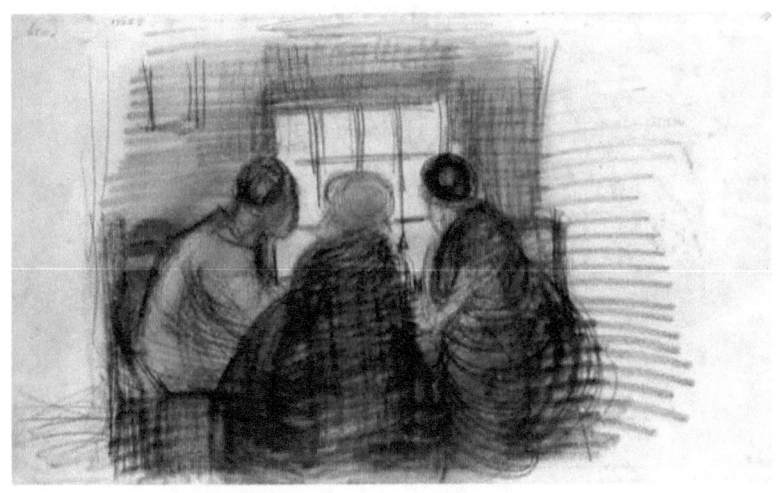

Three People Sharing a Meal

1885, Chalk

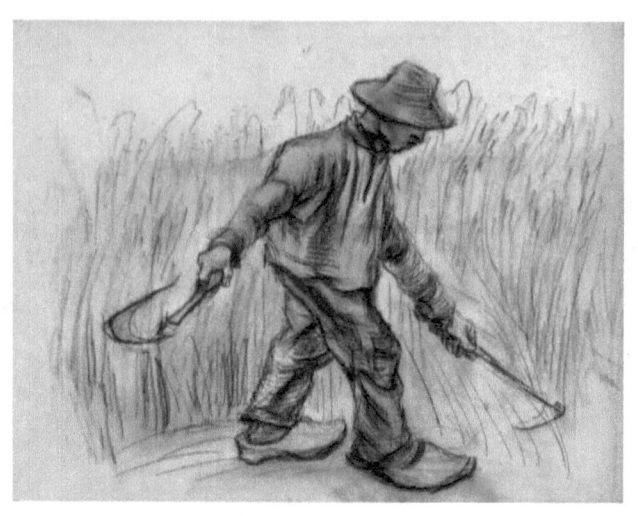

Reaper

1885, Chalk

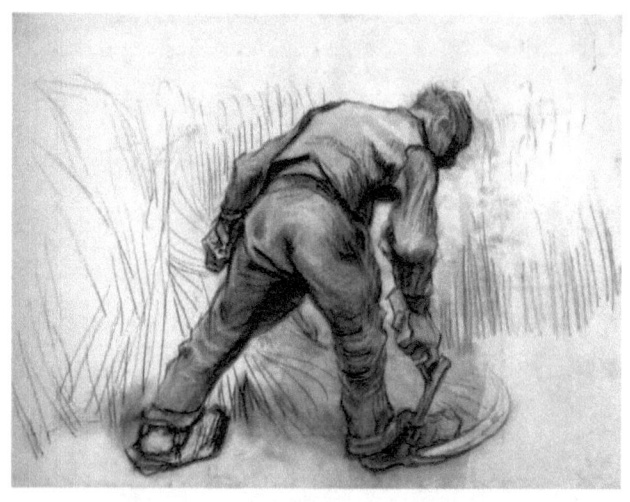

Reaper

1885, Chalk

Peasant Lifting Beet

1885, Chalk

Peasant with Sickle

1885, Chalk

Peasant Woman Lifting Potatoes

1885, Chalk

Plate with Cutlery and a Kettle

1885, Chalk

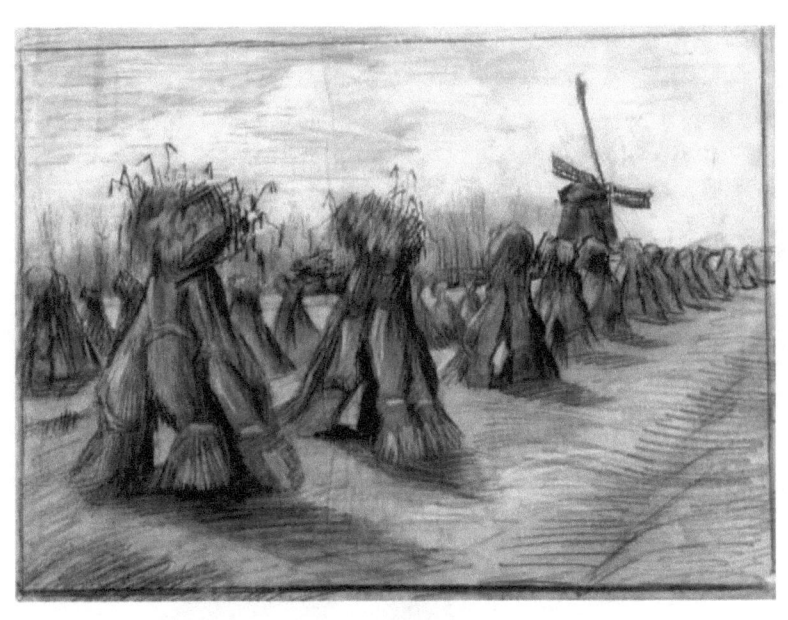

Wheat Field with Sheaves and a Windmill

1885, Chalk

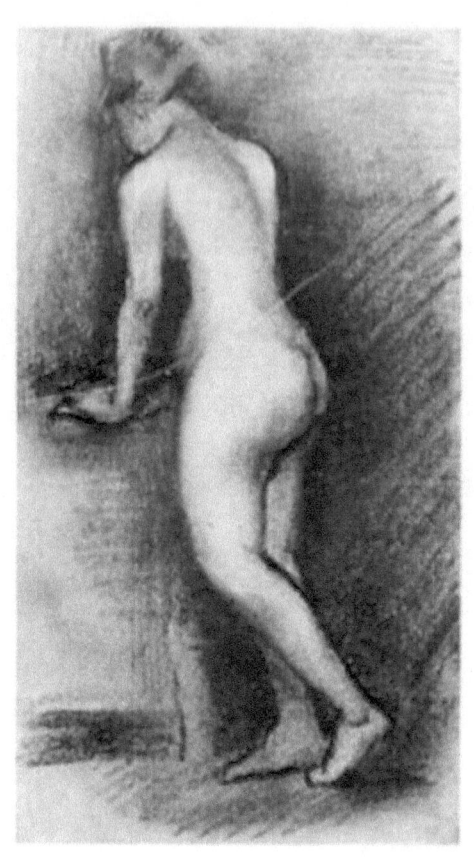

Female Nude, Standing

1886, Drawing, Black Chalk, Van Gogh Museum

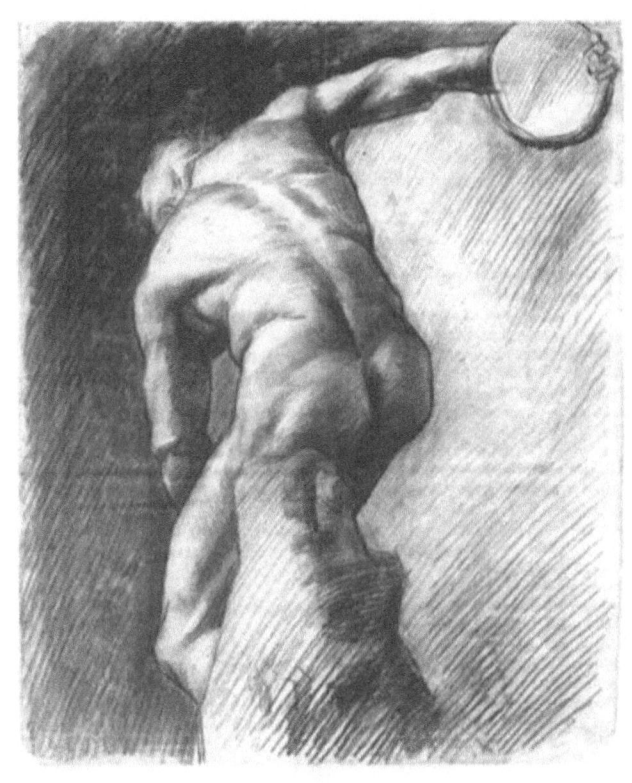

Discus Thrower, The

1886, Black Chalk, Van Gogh Museum

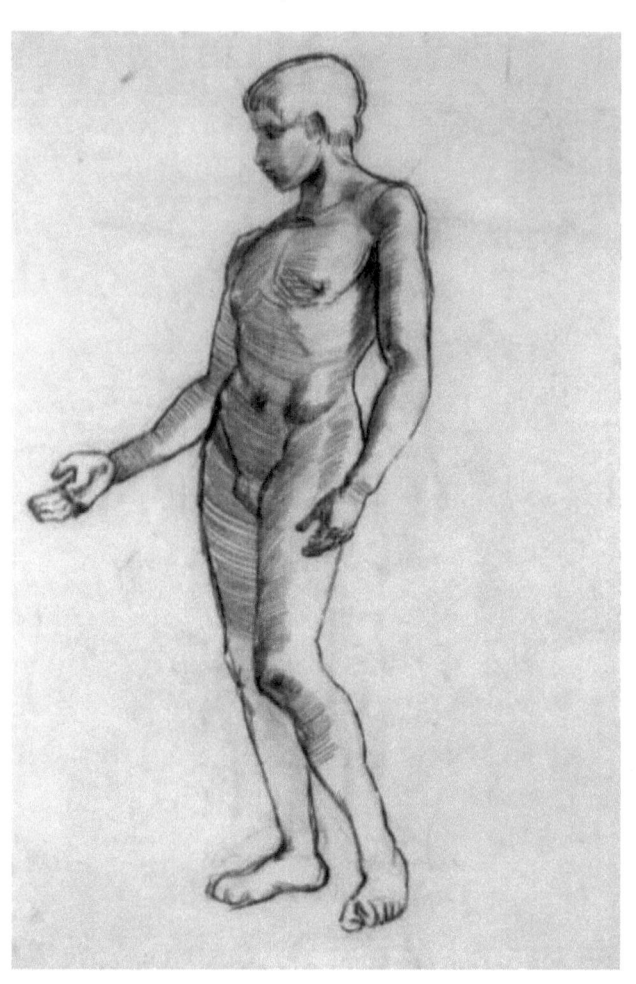

Idol

1886, Chalk

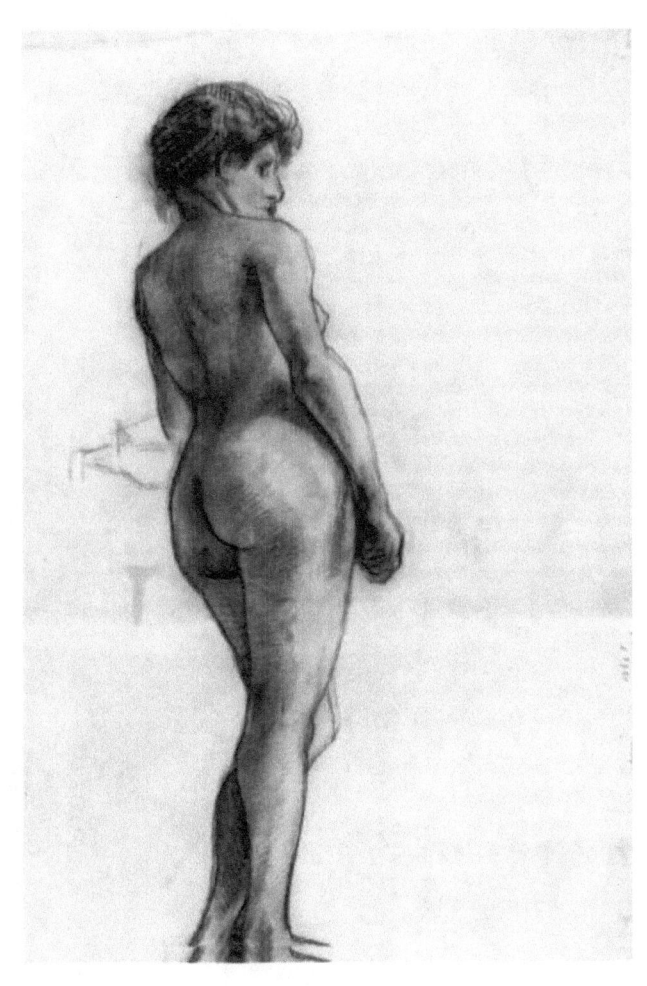

Standing Female Nude Seen from the Back

1886, Chalk

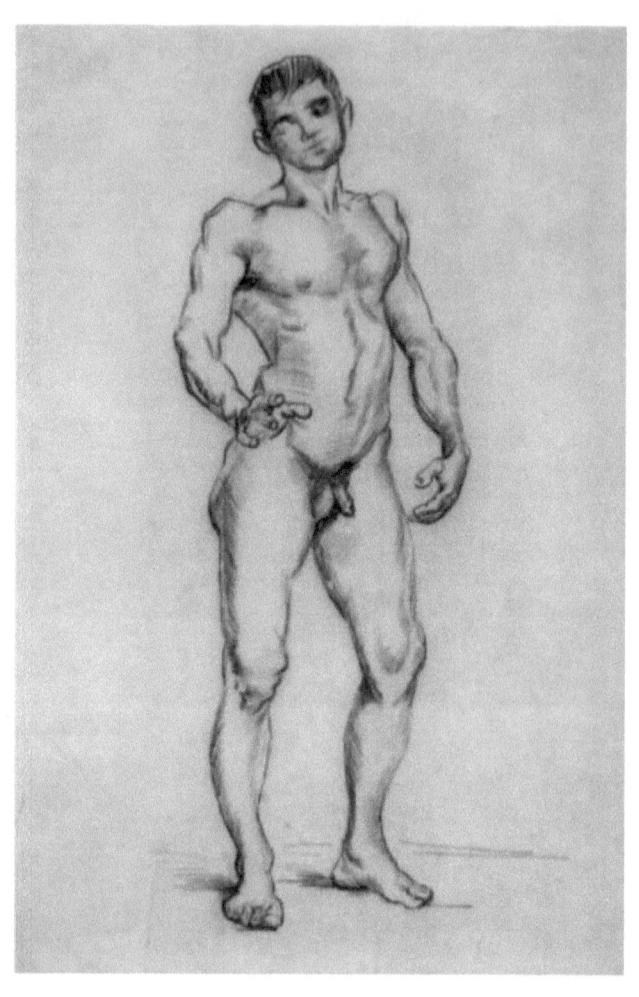

Standing Male Nude Seen from the Front

1886, Chalk

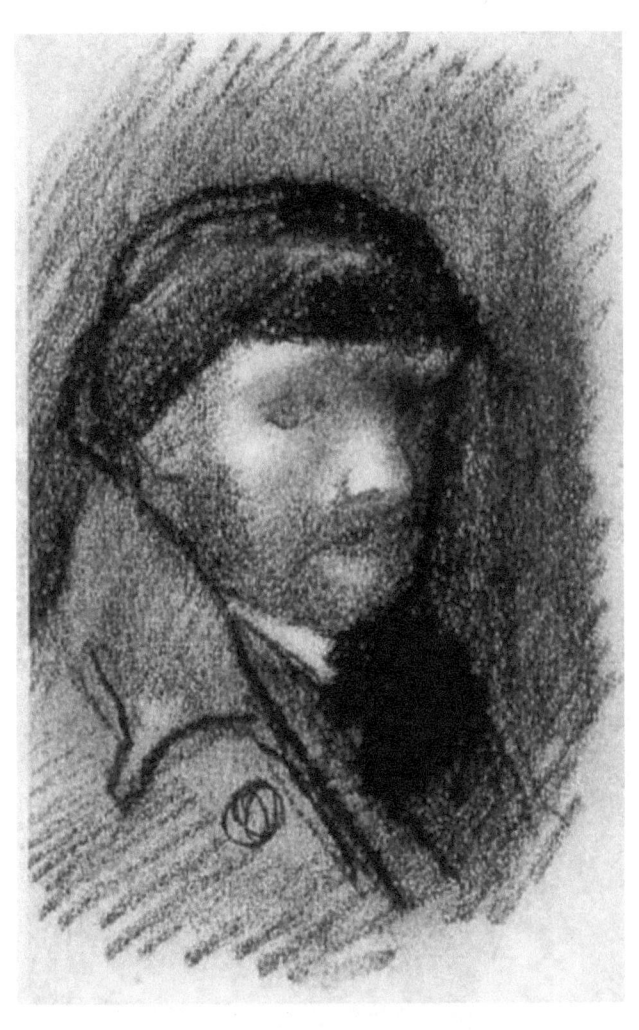

Self-Portrait with Cap

1886, Chalk

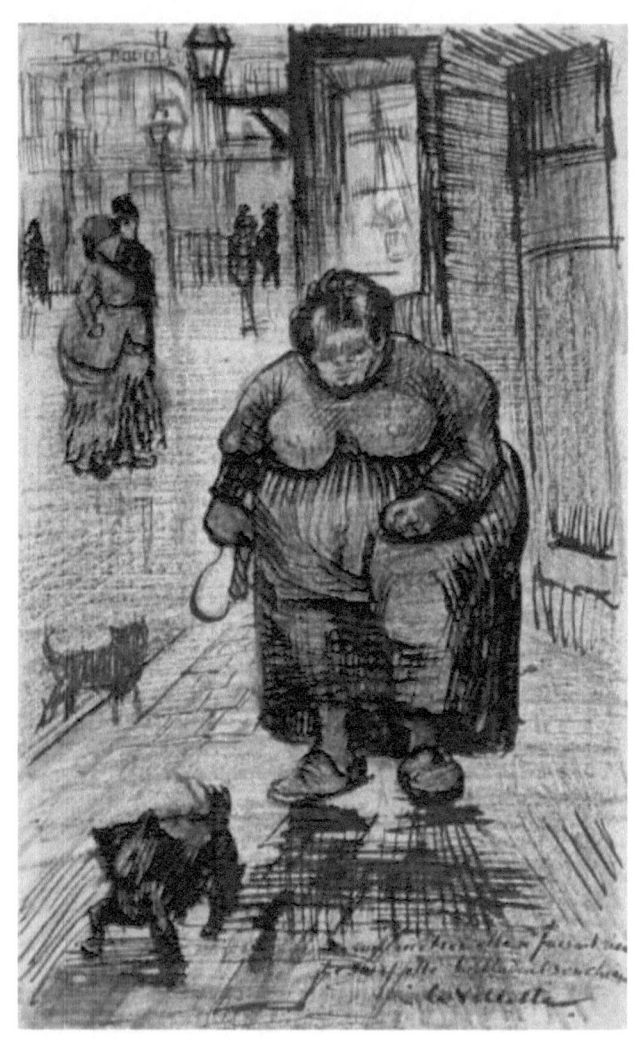

Woman Walking Her Dog

1886, Chalk

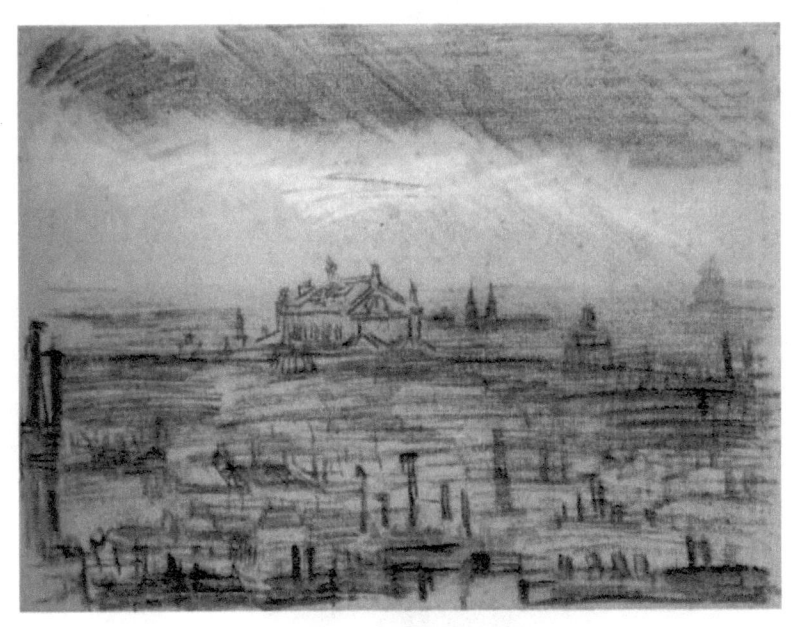

A View of Paris

1886, Chalk

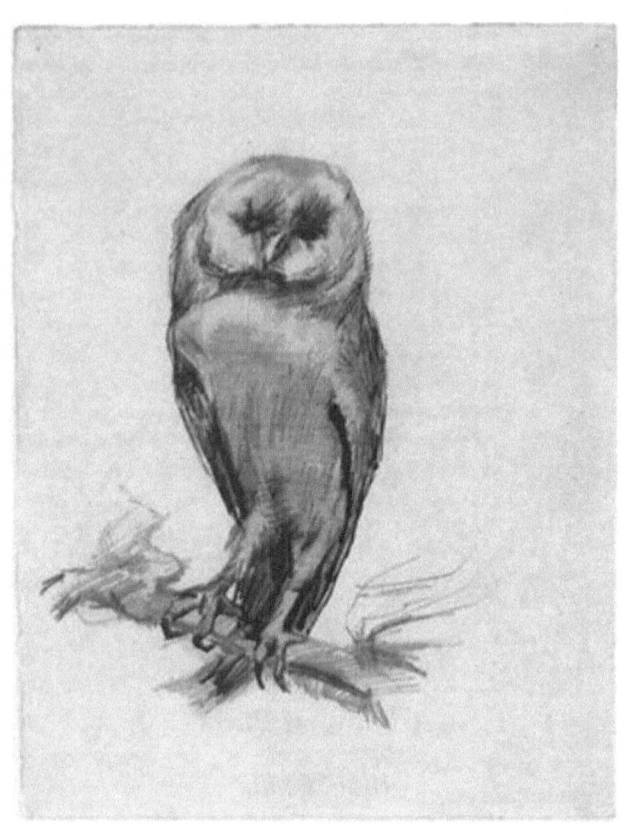

Barn Owl Viewed from the Front

1887, Drawing, Pencil, pen, blue ink, Van Gogh Museum

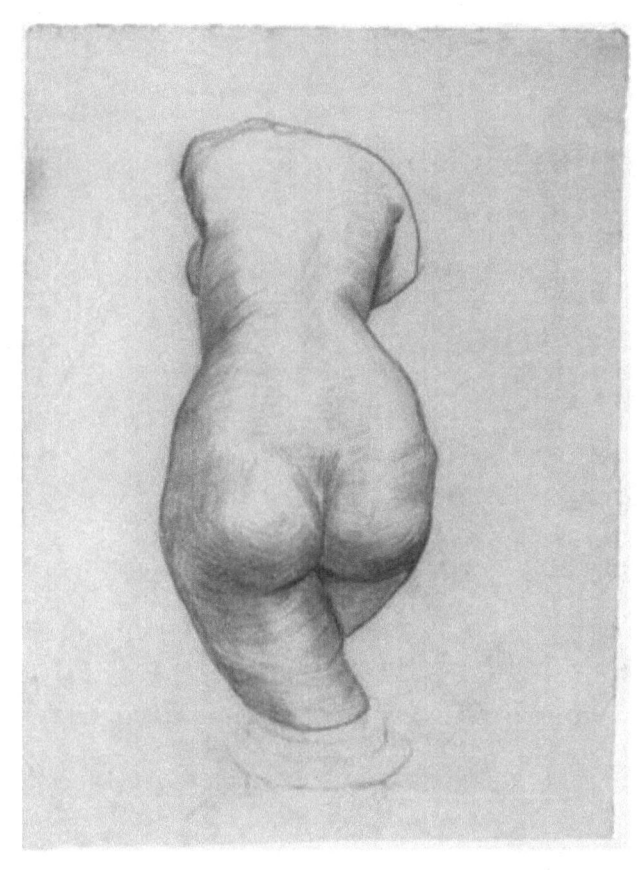

Torso of Venus

1886 - 87, Drawing, Black Chalk, Van Gogh Museum

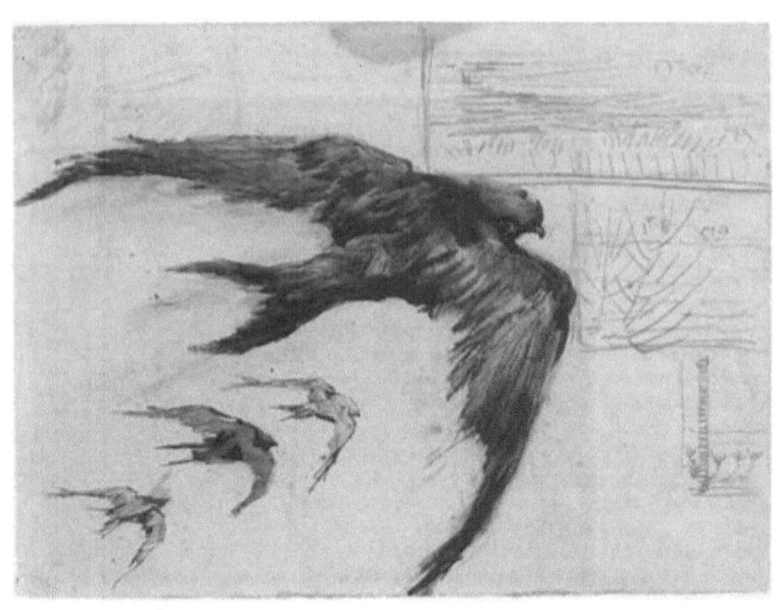

Four Swifts with Landscape Sketches

1887, Drawing, Pen, washed, Van Gogh Museum

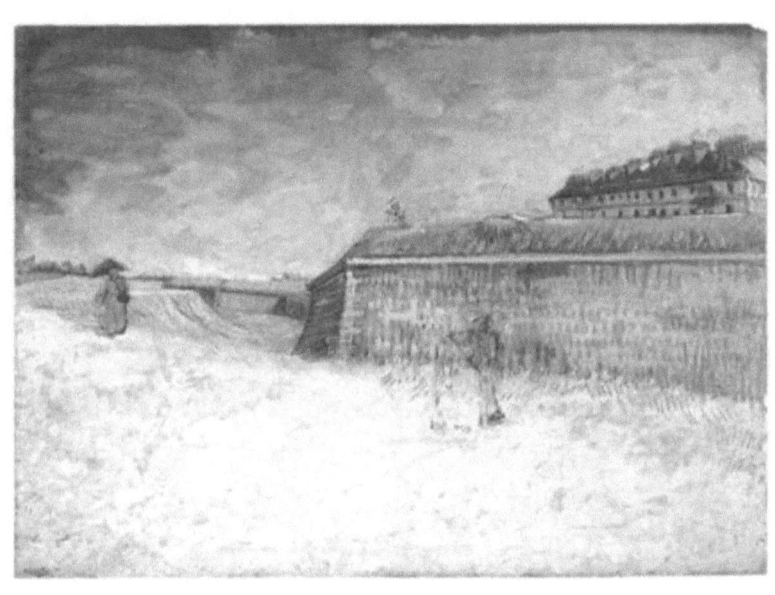

Ramparts of Paris, The

1887, Manchester, Whitworth Art Gallery, University of Manchester

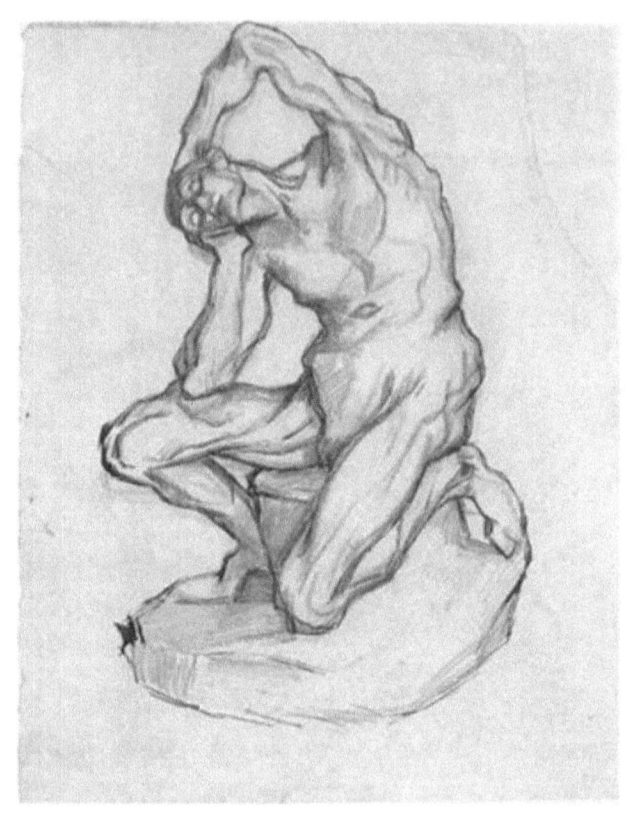

Kneeling Ecorche

1887, Drawing, Pencil, pen, Van Gogh Museum

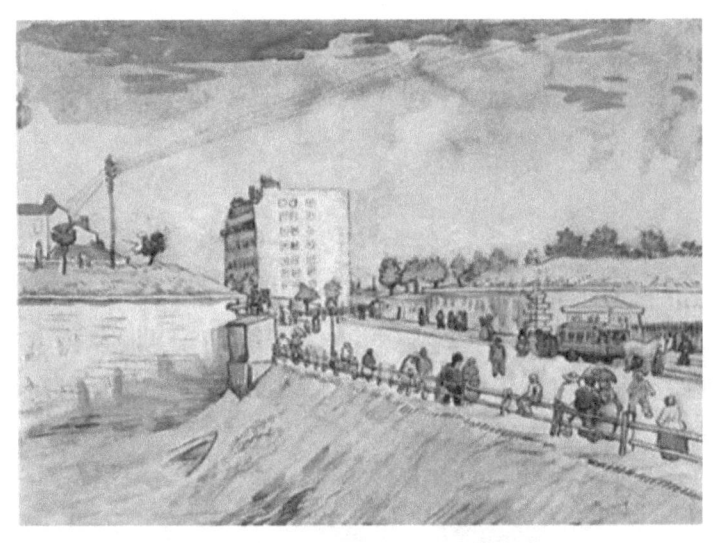

Gate in the Paris Ramparts

1887, Watercolor, Amsterdam, Van Gogh Museum

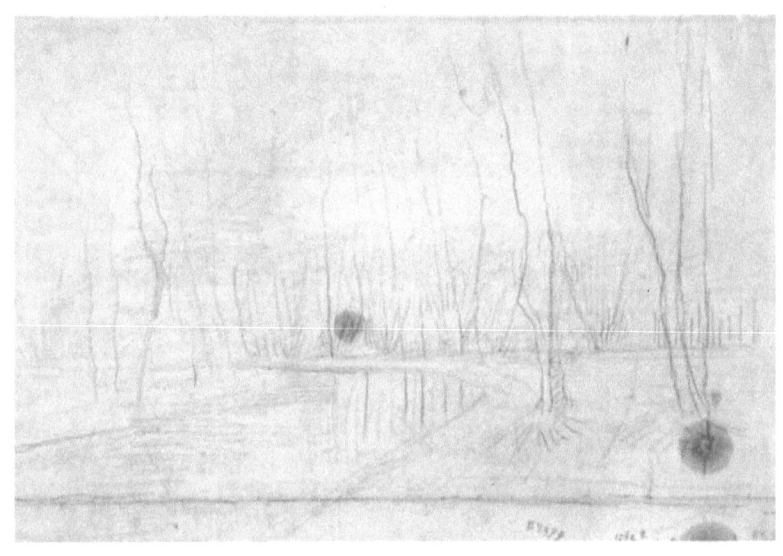

Park View

1887, Chalk

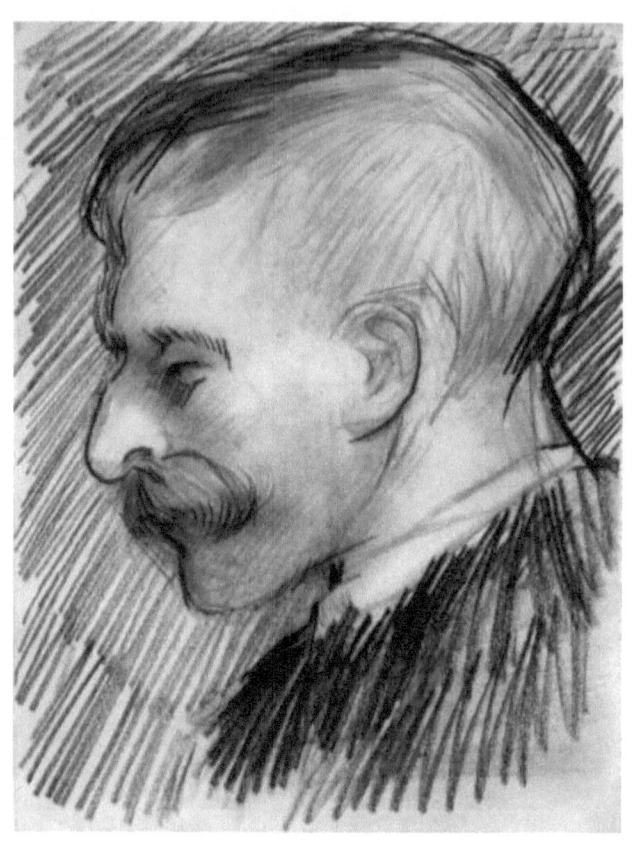

Head of a Man (Possibly Theo van Gogh)

1887, Chalk

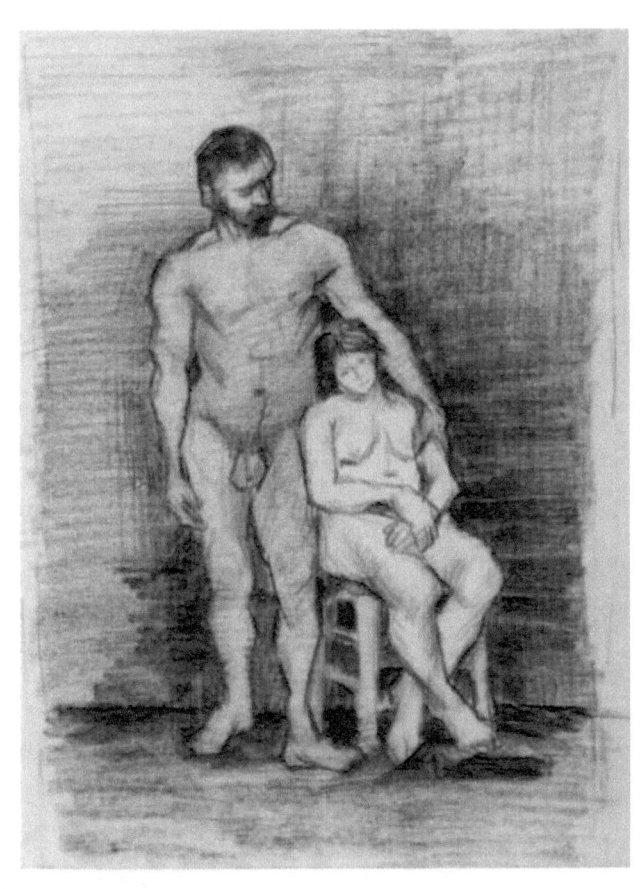

Standing Male and Seated Female Nudes

1887, Chalk

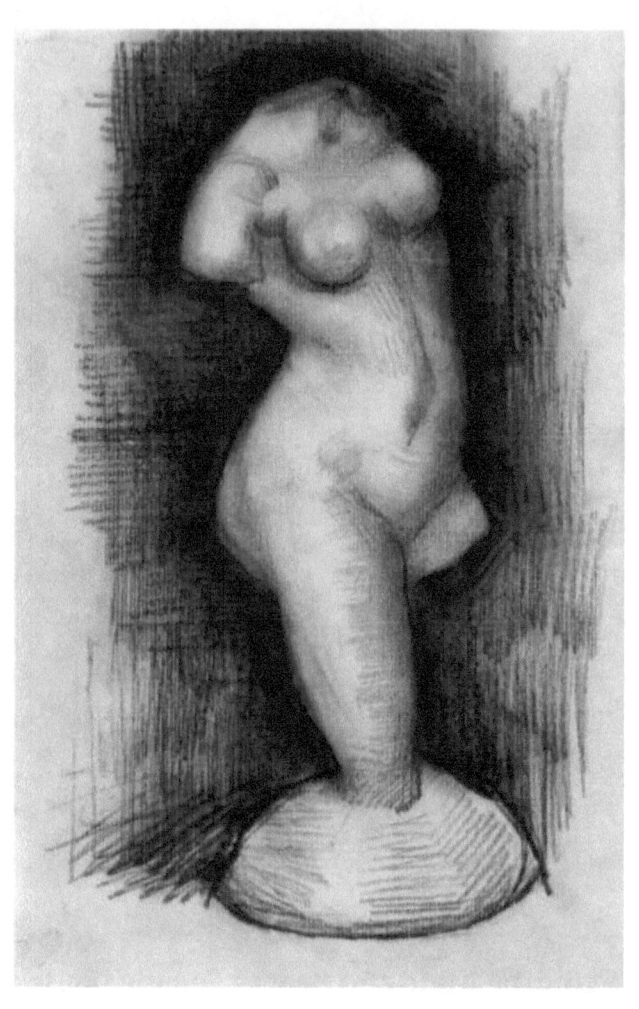

Torso of Venus

1887, Chalk

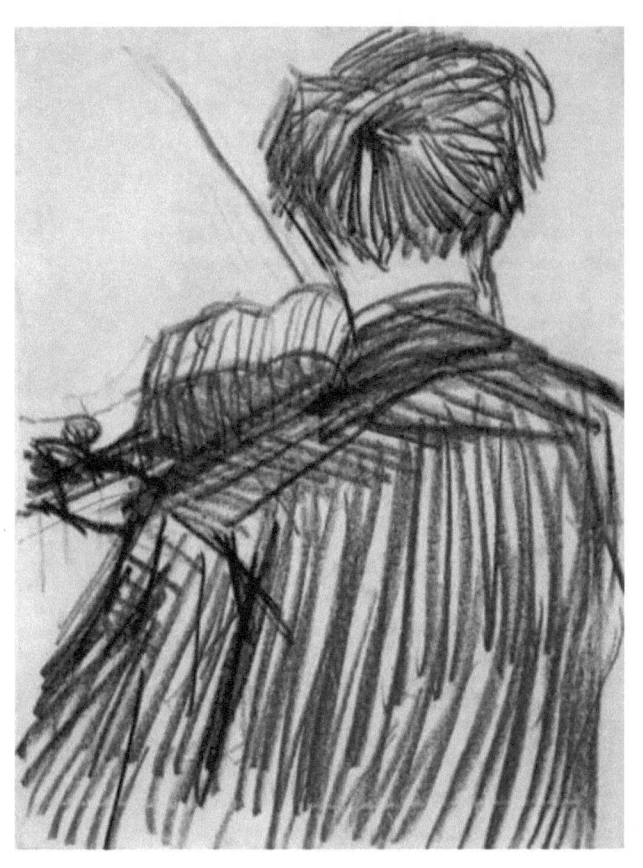

Violinist Seen from the Back

1887, Chalk

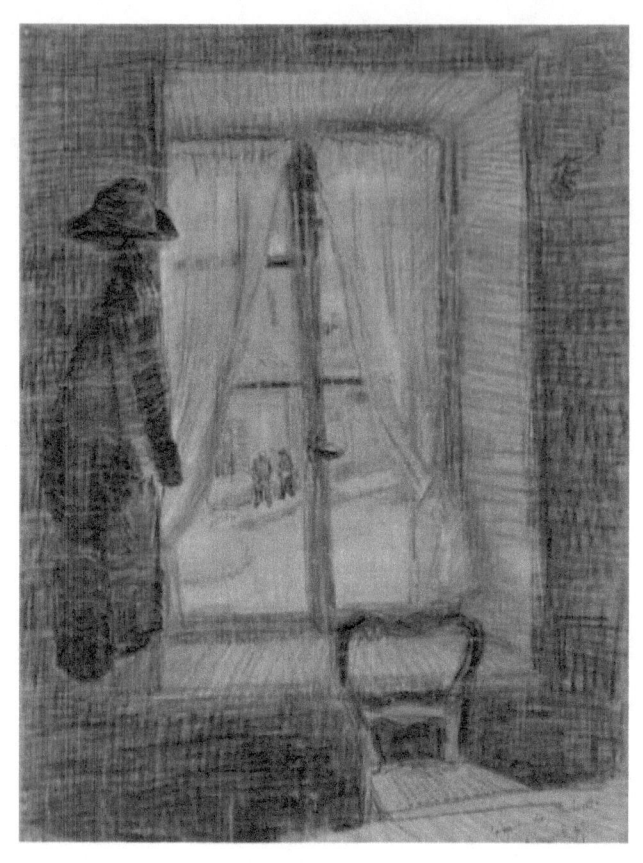

Window in the Bataille Restaurant

1887, Chalk

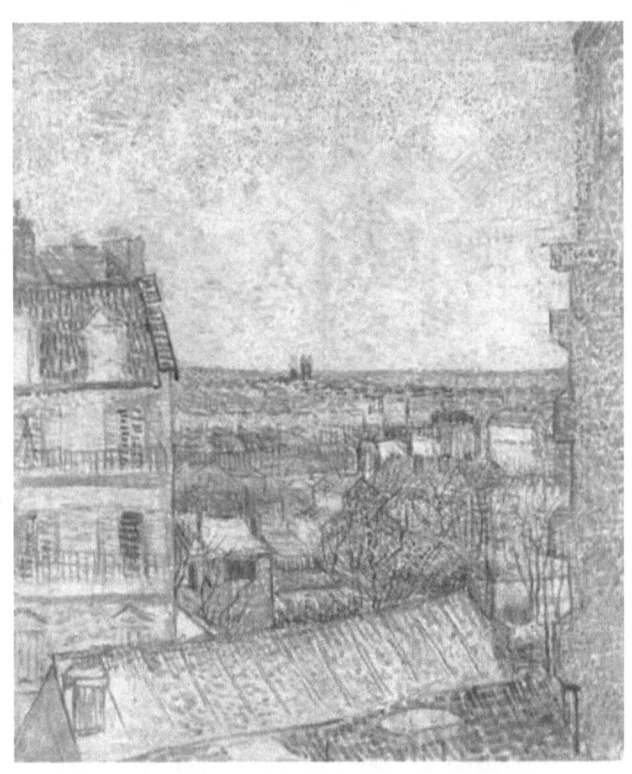

View from the Artist's Room, Rue Lepic

1887, Oil and pencil on board, 56 x 38 cm, Private Collection

Painted in Paris in the spring of 1887, Vue de la chambre de l'artiste depicts the view from the apartment on the Rue Lepic that Van Gogh shared with his brother Theo. The two years that Van Gogh spent in Paris, from March 1886 until February 1888, represent a pivotal period in his career, during which he assimilated a host of diverse artistic currents and forged a strongly personal style. With its range of creative influences, from pointilism to Japanese prints, the present picture exemplifies the experimental passion of this era.

The apartment on the Rue Lepic looked out over an impressive view of Paris, which Theo described in a letter dated July 1887: "The remarkable thing about our dwelling is that one has a magnificent view of the whole town, with the hills of Meudon and St. Cloud on the horizon, and over it an expanse of sky nearly as large as when one is standing on the top of a dune. With the different effects produced by the various changes in the sky, it is a subject for I don't know how many pictures". Van Gogh first painted the view from the apartment in mid-1886, producing four panoramic vistas in a muted palette of browns and grays. The twin spires of the Church of Notre-Dame, visible on the horizon in the present painting, are discernible in one of the 1886 oils as well. Van Gogh returned to the theme in the early spring of the following year, when the tree branches were still bare. Working now with a lightened palette, he painted the present picture and a closely related canvas. He also made a series of five large, detailed drawings.

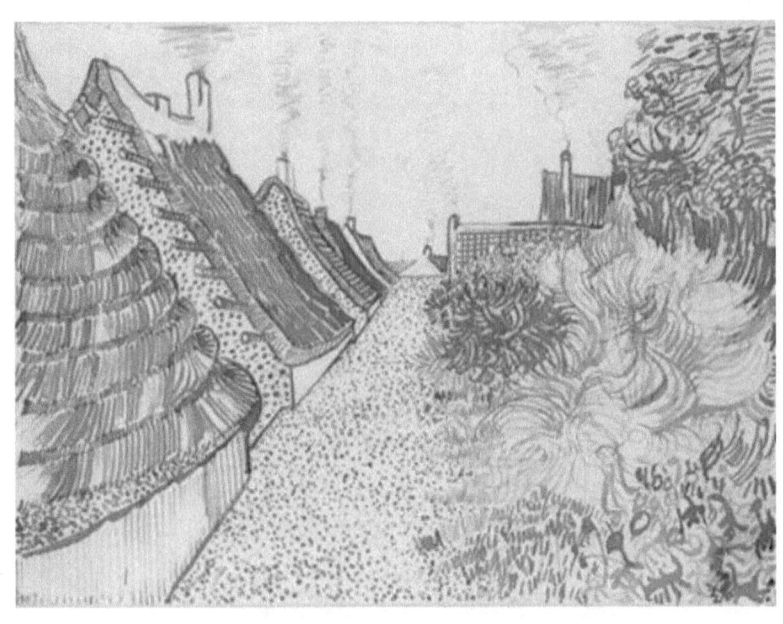

Street in Saintes-Maries

1888, Pens (including reed pen), brush, and iron gall ink over Chalk on wove paper (backed with wove paper), Metropolitan museum

In the summer of 1888, Van Gogh, who was then living in Arles, made a trip to the small Mediterranean fishing village of Saintes-Maries de la Mer, where he made a painted view of this street with its thatched roofs and smoking chimneys. This drawing was one of fifteen that were sent, in the month of July alone, to Van Gogh's friend, the artist Émile Bernard, in Brittany, to keep Bernard up to date on the work he was doing. In these vibrant drawings, Van Gogh captured the essence of the paintings while creating the compositions anew in a different medium.

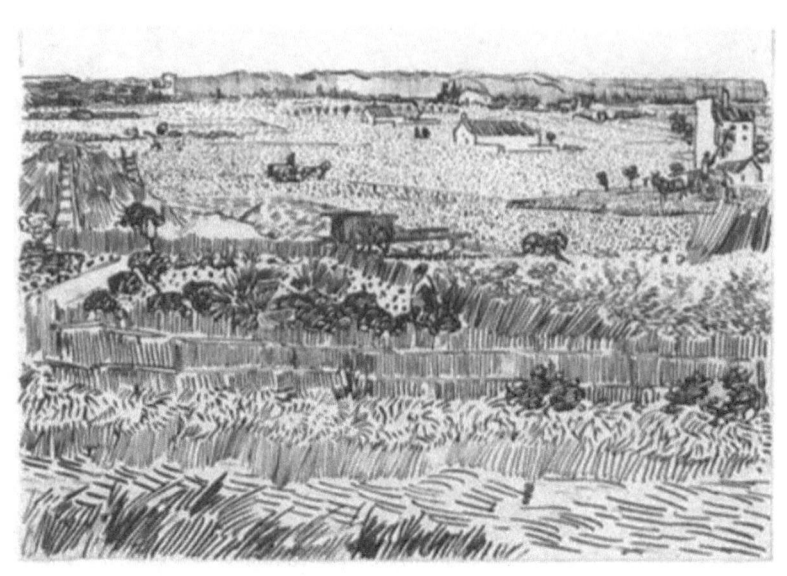

Harvest Landscape

1888, Drawing, Pen, Kupferstichkabinett, Berlin, Germany

Orchard with Blossoming Plum Trees

1888, Drawing, Reed pen, heightened with white, Van Gogh Museum

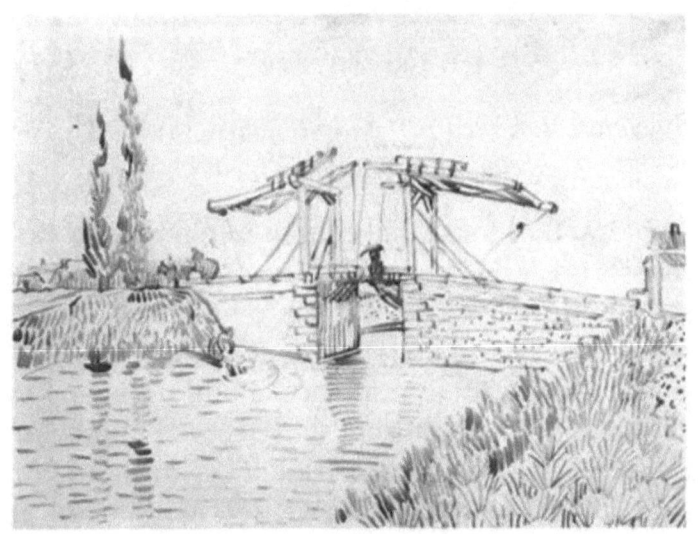

Drawbridge with Lady with Parasol

1888, Drawing, Pen, Los Angeles County Museum of Art

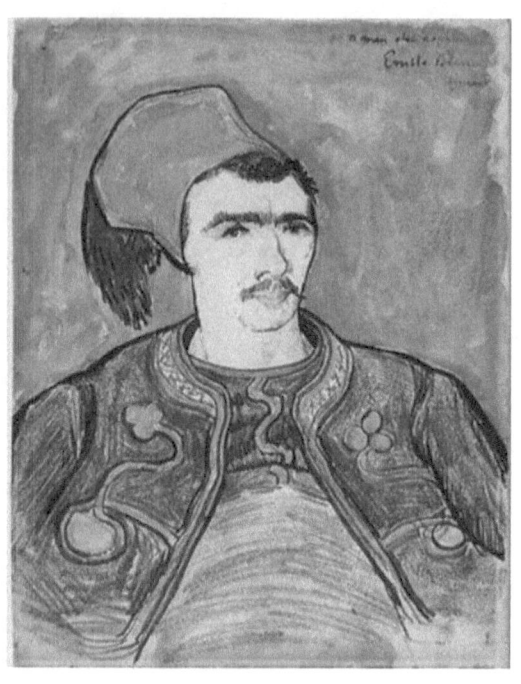

The Zouave

1888, Watercolor, reed pen and ink, wax crayon, 31.5 x 23.6 cm, Metropolitan Museum

During a spell of torrential rain that interrupted his harvest series, Van Gogh made his first real effort at portraiture in Arles. Two days into his campaign, he announced to Theo: "I have a model at last—a Zouave—a boy with a small face, a bull neck, and the eye of the tiger." The present work served as a color study for his bust-length portrait of the dashing young soldier. In the oil painting, Van Gogh heightened the "savage combination of incongruous tones," fleshed out the character's likeness, and placed him in a convincing setting. That July he sent the watercolor, with dedicatory inscription, to his "comrade Émile Bernard."

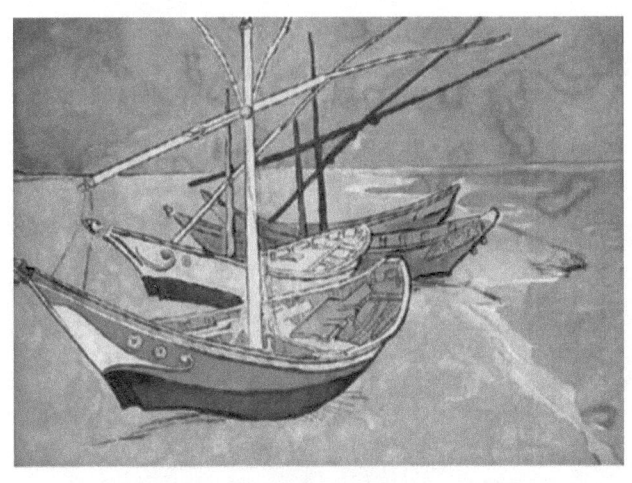

Fishing Boats on the Beach

1888, Watercolor, Hermitage, St. Petersburg

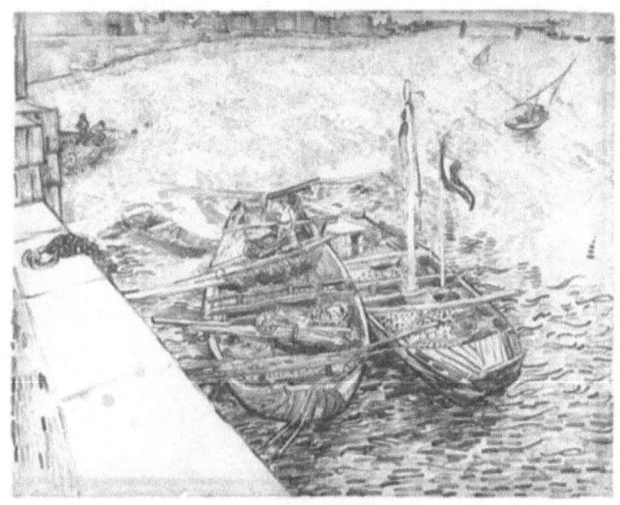

Quay with Men Unloading Sand Barges

1888, Drawing, Pencil, reed and quill pens and black and brown ink on Whatman paper, The Cooper Hewitt Museum, New York, New York

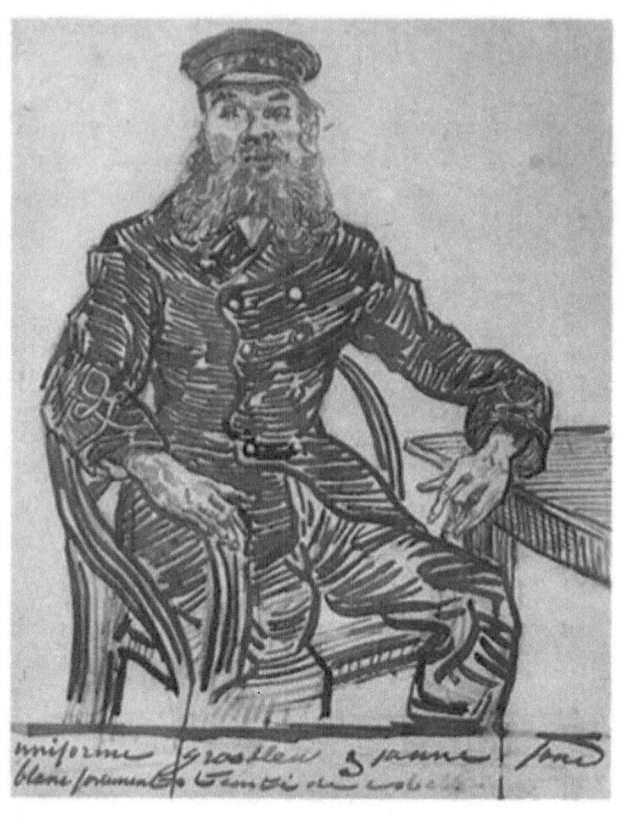

Joseph Roulin, Sitting in a Cane Chair, Three-Quarter-Length

1888, Drawing, Pen, Private collection

Pink Peach Trees

1888, Watercolor, Van Gogh Museum

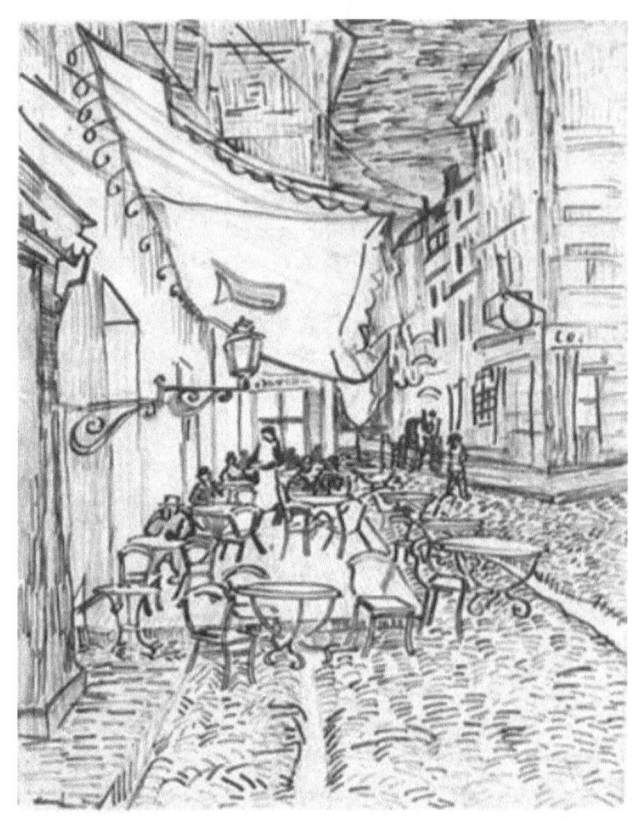

Cafe Terrace on the Place du Forum, Arles

1888, Drawing, Pen, reed, ink, pencil on laid paper, Dallas Museum of Art

Cafe Terrace on the Place du Forum, Arles

1888, Drawing, Pen, reed, ink, pencil on laid paper, Dallas Museum of Art

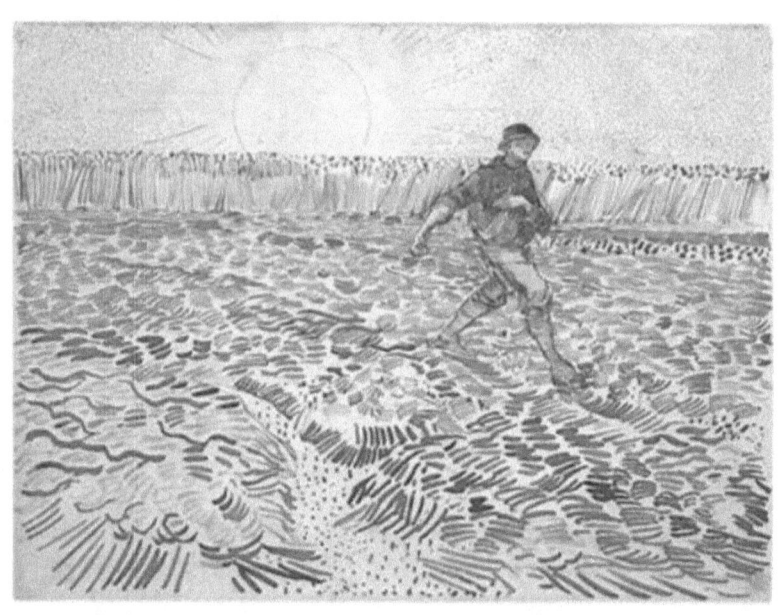

Sower with Setting Sun

1888, Drawing, Reed pen, Van Gogh Museum

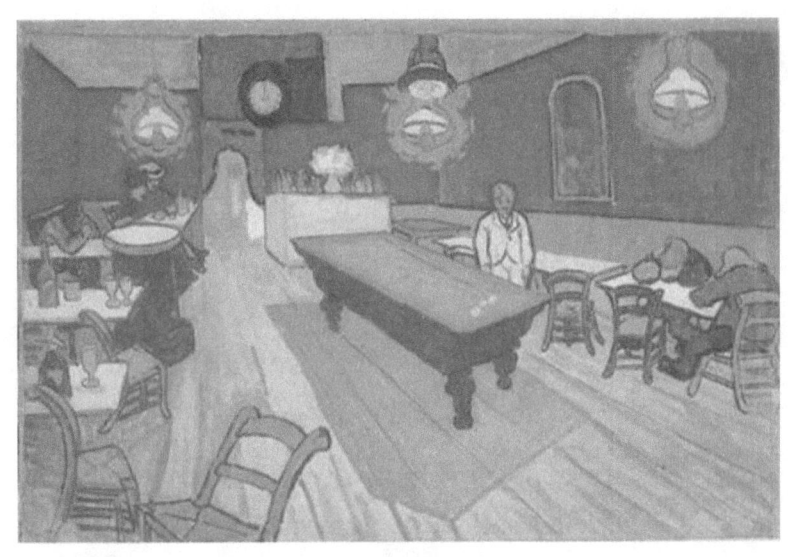

Night Cafe in Arles

1888, Watercolor, Bern, Collection H.R. Hahnloser

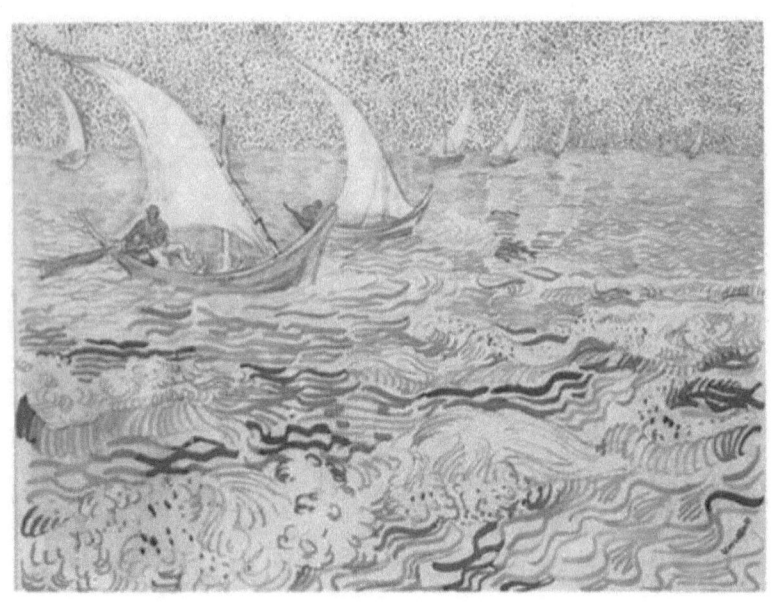

Fishing Boats at Sea

1888, Pencil, reed pen, quill and black ink on wove paper, Musee d'Art Moderne, Musees Royaux des Beaux-Art de Belgique

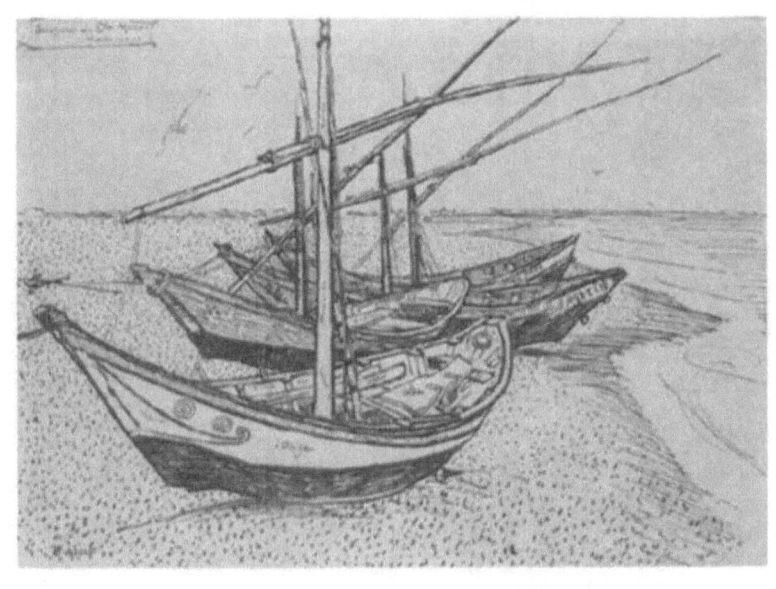

Fishing Boats on the Beach at Saintes-Maries

1888, Drawing, reed pen, Private collection

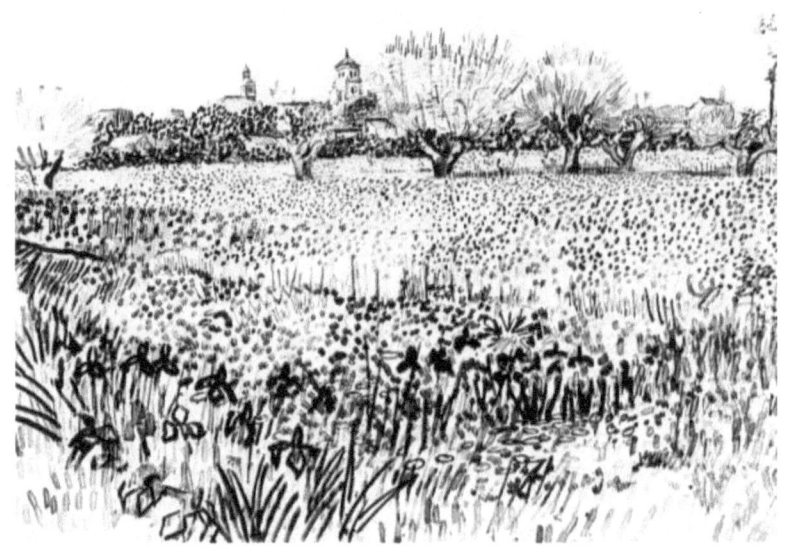

Field with Flowers

1888, Chalk

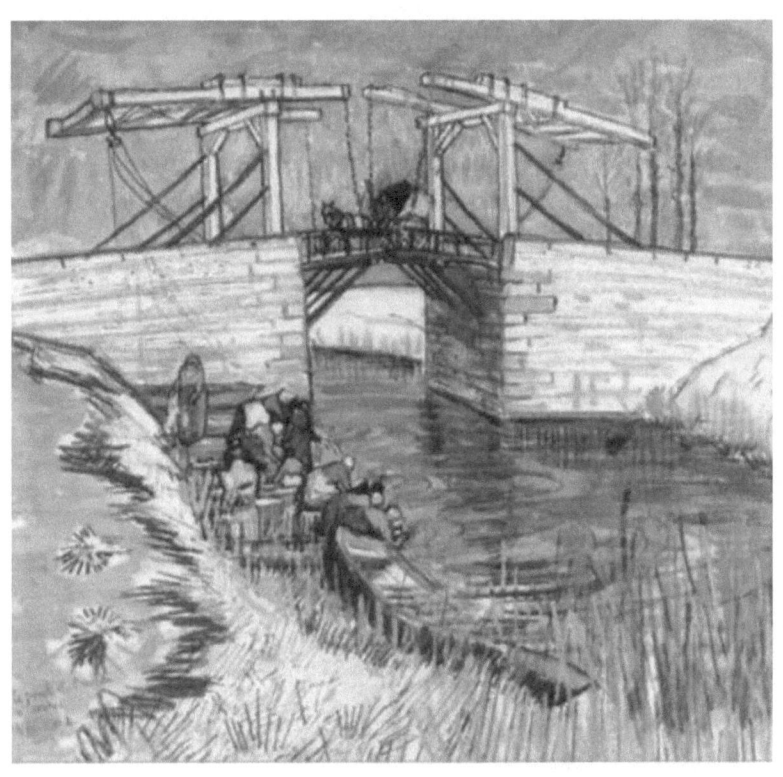

Le pont de Langlois à Arles

1888, Watercolor, Gouache, Chalk, pen and ink over pencil on paper, 30.5 x 30.2 cm, Private Collection

Executed in April 1888, Le pont de Langlois à Arles is one of a series of views of the Langlois Bridge at Arles that van Gogh painted between mid-March and mid-May of 1888. These pictures are among the most celebrated and recognizable paintings from his sojourn in the South - the fifteen months that van Gogh spent at Arles represent the essential moment in his career, in which he integrated the results of months of

experimentation and produced some of his most renowned masterpieces. With their forceful palette and bold design, the Langlois Bridge pictures epitomize his mature style. Van Gogh was justifiably proud of these works, and Ronald Pickvance has pointed out that early in his stay he chose to send Le pont de Langlois à Arles to his brother to illustrate one of the works he had created there.

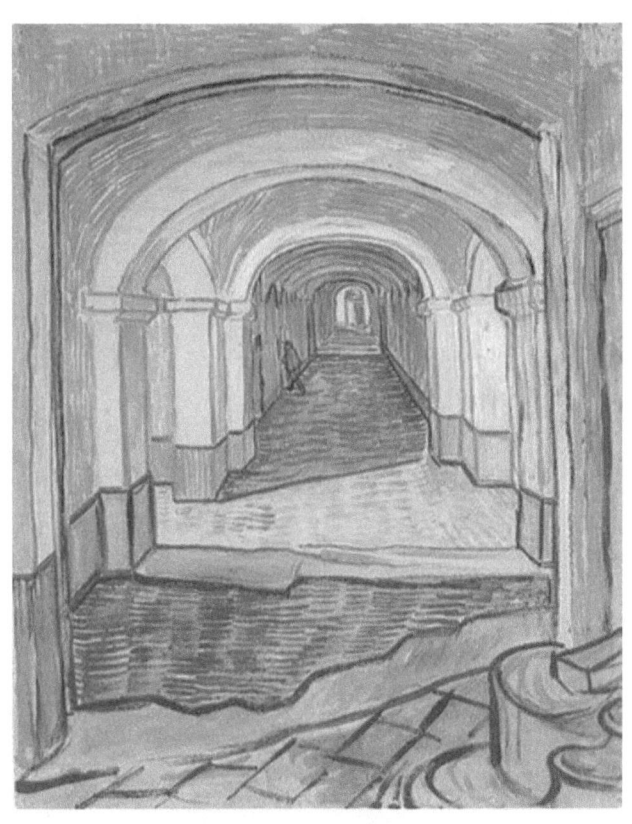

A Corridor in the Asylum

1889, Black Chalk and Gouache on pink Ingres paper, 65.1 x 49.1 cm, Private Collection

This haunting view of a sharply receding corridor is the artist's most powerful depiction of the asylum of Saint-Paul-de-Mausole in Saint-Rémy, where he spent twelve months near the end of his life and where he painted the Museum's oils of olive groves, cypresses, roses, and irises. The buildings (largely remains of a twelfth-century monastery) were divided into men's and

women's wards, but most of the small cells looking out on the neglected garden were empty when Van Gogh was there. One of the rooms he was able to use as a studio. The artist sent this unusually large and colorful drawing to his brother Theo, to give a picture of his surroundings.

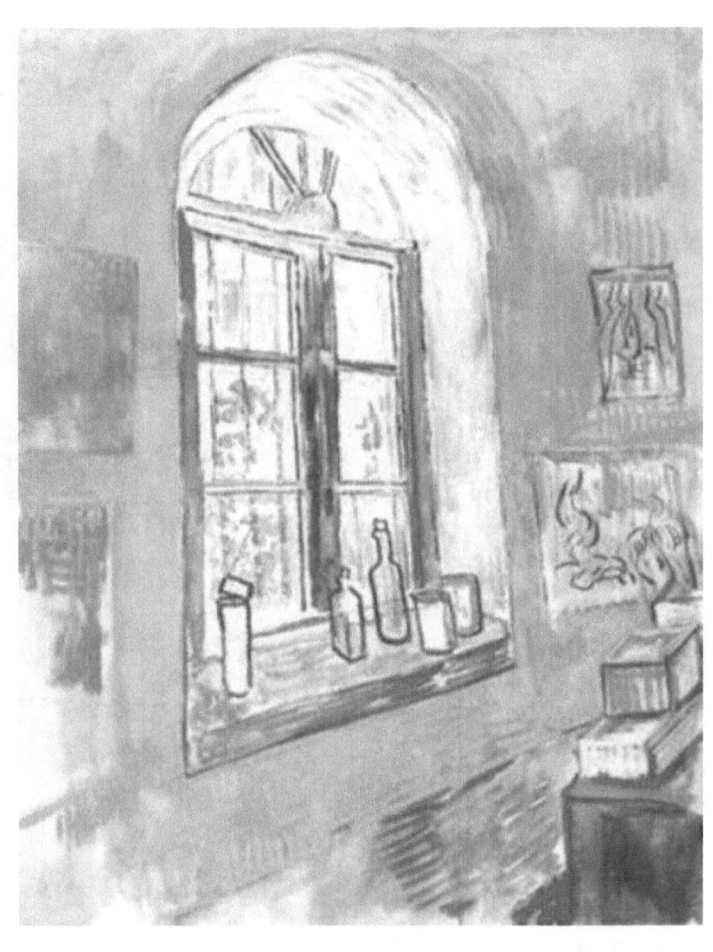

Window of Vincent's Studio at the Asylum

1889, Watercolor, Amsterdam, Van Gogh Museum

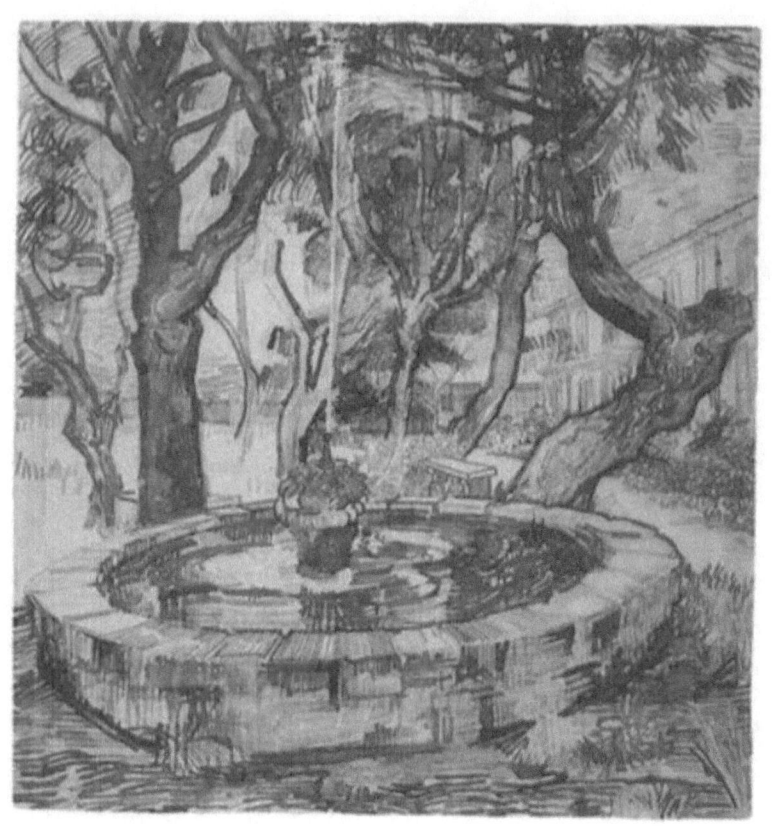

Fountain in the Garden of Saint-Paul Hospital

1889, Drawing, Black Chalk, reed pen and ink, Van Gogh Museum

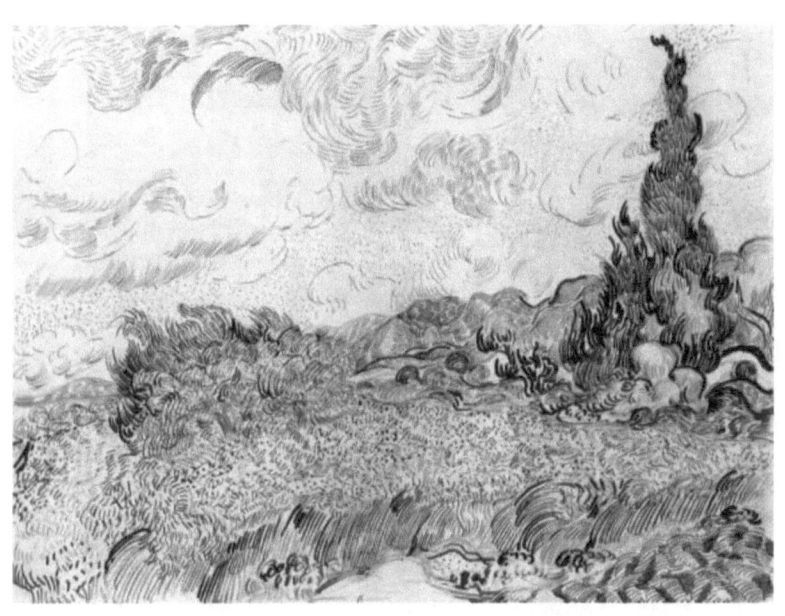

Wheat Field with Cypresses at the Haude Galline near Eygalieres

1889, Chalk

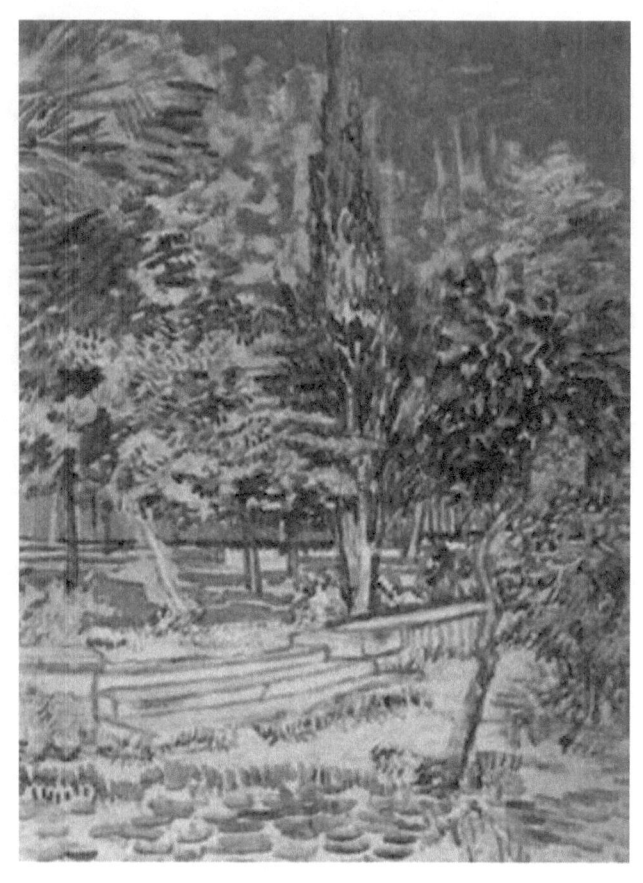

Stone Steps in the Garden of the Asylum

1889, Watercolor, Amsterdam, Van Gogh Museum

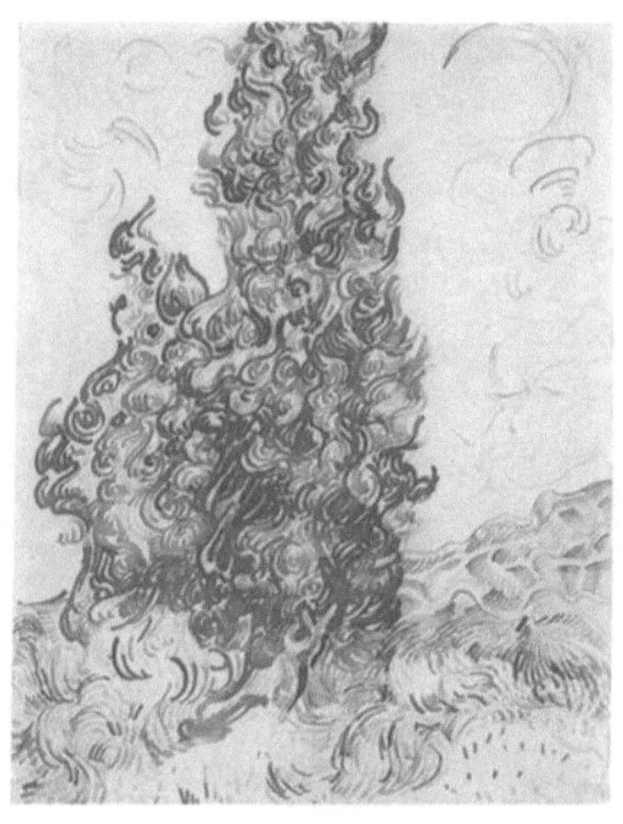

Cypresses

1889, Drawing, Pencil, reed peen, and ink, The Brooklyn Museum

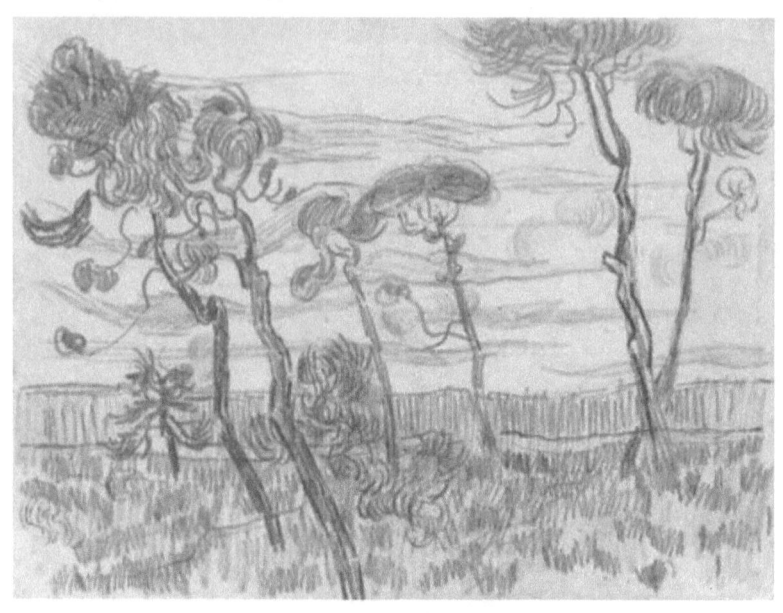

Six pines near the enclosure wall

1889, Charcoal and pencil on paper, 25 x 32.5 cm, Private Collection

The legendary quarrel between Van Gogh and Gauguin in Arles, in December 1888, was the first, dramatic manifestation of Vincent's mental instability, which was to express itself repeatedly during the next year and a half in the forms of periods of extreme depression, followed by moments of complete apathy.

After a second breakdown in February 1889, Arles' Reverend Salles wrote to Theo warning him that a petition signed by his neighbors had confined his brother to a special cell in the hospital. In May, Reverend Salles asked Theo's consent to have Vincent

committed to the asylum of Saint Rémy de Provence (about fifteen miles north-est of Arles), which was housed in the 12th Century monastery of Saint-Paul de Mausole. On 8 May, he accompanied a 'completely calm' Vincent to the asylum. In the asylum, thanks to Theo's intercession, Vincent was treated as a special patient: in addition to the cell where he slept (on the second floor), he had a room at his disposal for use as a studio (on the second floor). The building was surrounded by a large garden with flowers and pine trees, enclosed by a fenced wall - which we see in the present drawing, silhouetted against the tormented sky.

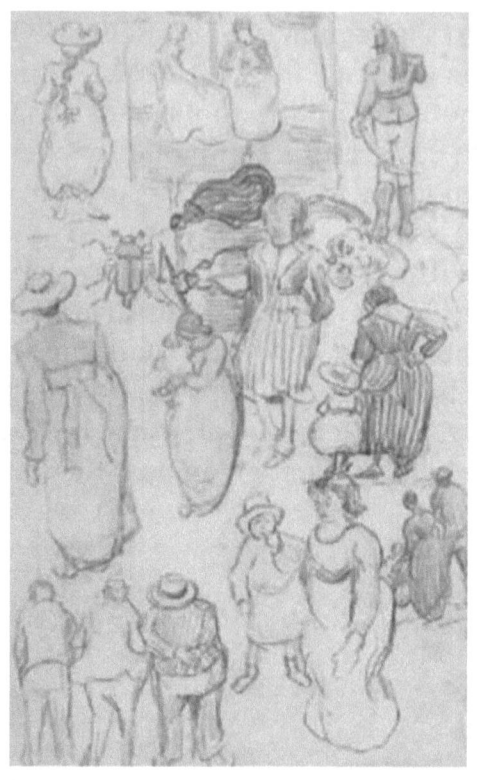

Figure Sketches (recto); Sketches of a young woman (verso)

1890, Pencil on paper, 44.3 x 27.3 cm, Private Collection

The present sheet is the most articulate and complex of a series of multi-study drawings executed by van Gogh in July 1890 in Auvers, a month before his death. This work is the only one from this group still in private hands; the others are housed today in the Louvre, the Fine Arts Museum of San Francisco and the Rijksmuseum Vincent van Gogh, Amsterdam.

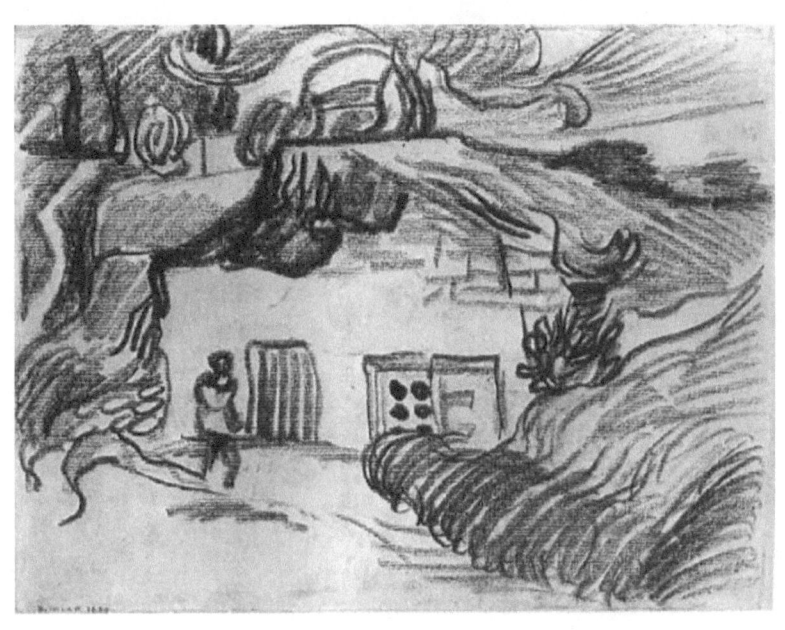

Houses among Trees with a Figure

1890, Chalk

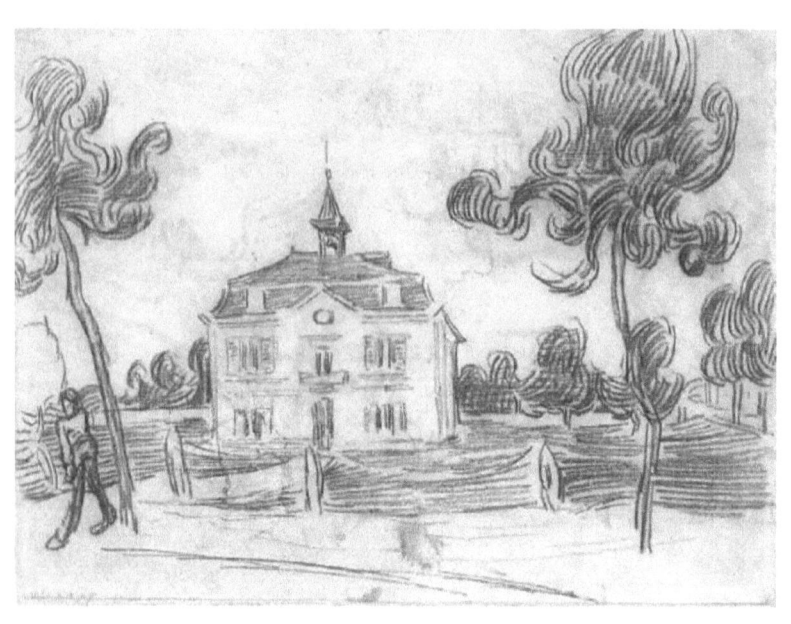

The Town Hall at Auvers

1890, Chalk

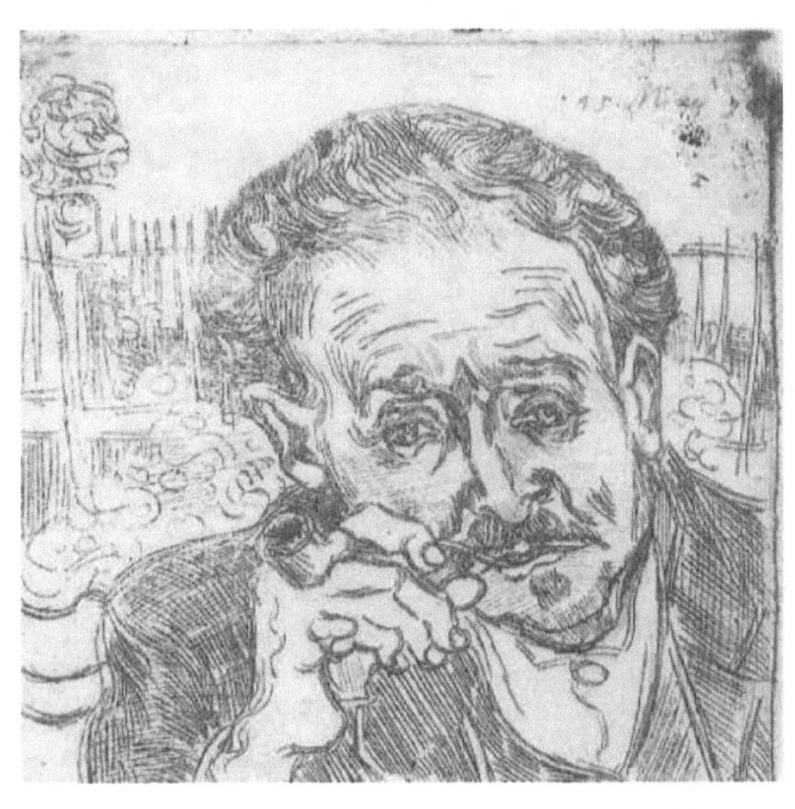

Portrait of Doctor Gachet (A man with pipe)

1890, Chalk

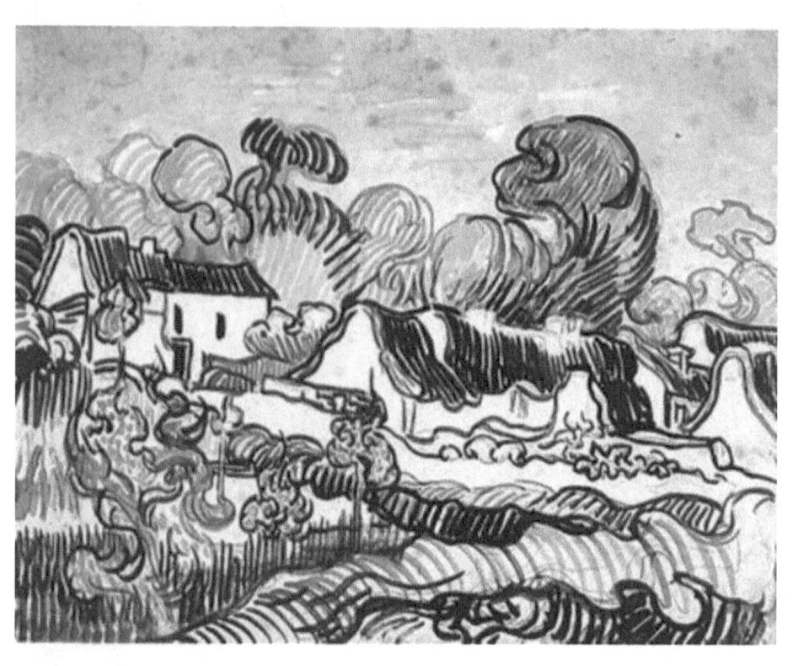

Landscape with Cottages

1890, Watercolor, Amsterdam, Van Gogh Museum

www.ingramcontent.com/pod-product-compliance
Lightning Source LLC
Chambersburg PA
CBHW020917180526
45163CB00007B/2772